REFLECTIONS OF CHRIST

REFLECTIONS OF CHRIST

MARK MABRY

REFLECTIONS

MEDIA GROUP

Visit us at www.ReflectionsofChrist.org

Library of Congress Cataloging-in-Publication Data

Mabry, Mark.

 Reflections of Christ / Mark Mabry.

 p. cm.

 ISBN 978-1-60641-027-1 (hardbound : alk. paper)

 1. Christian life—Pictorial works. 2. Jesus Christ—Art. 3. Portrait photography. 4. Mabry, Mark. I. Title.

 BV4515.3.M33 2008

 242—dc22

 2008030493

Printed in the United States of America

Inland Graphics, Menomonee Falls, WI

10 9 8 7 6 5 4 3

To Tara, for having the patience to be married to an artist

To Marko, Bowan, and Ava, so they'll always remember their Dad believes in the Savior

To everyone who added their witness of Christ to this book

PREFACE

Am I where I can do the most good?" As a twenty-nine-year-old portrait photographer with a relatively successful studio, I knelt to ask God this question. Is photography where I would be able to do the most good? I had studied political science and Russian at Arizona State University, but now, seven years later, I was questioning my decision to bail on my studies and attend an art school instead.

I knew commercial photography often doesn't leave many avenues for righteous pursuit without compromising one's beliefs. Some people can find those avenues; many cannot.

The nearer it came to my thirtieth birthday, the more nervous I was about my future. The prayers continued, quietly, so as not to upset my wife with the news that I was entertaining different career options. I never got the brilliant, one-shot answer that I anticipated and sought. Instead, I was given a year-long series of step-by-step, life-changing promptings.

"Change your music." The voice was that simple and that direct. My iPod was filled with everything from hip-hop to alternative music—some of which was worthwhile, much of it not. So, I cleaned out my music storage. Changing my music lifted my spirit. I could go in and out of mental prayer without much white noise. I could love deeper and communicate better. My command of the language improved.

"Throw away your art books." I attended an early-morning meeting for men at my church. The speaker's topic was the evil of pornography. While pornography isn't an issue for me, I was riveted by the statistics of men and women addicted to it. As a father of two sons, I began to fear for them. Pornography is the dark side of photography—another manifestation of its power.

I thought about how in art school, it was not uncommon for an instructor to use "artistic nude" photographs to illustrate the beauty of light and the human form. At first I was caught off-guard by the images, but soon I began to accept that it wasn't pornography, but art. As I sat in the meeting that day, my mind turned to my growing collection of books by legendary photographers. Most of them had "artistic nudes" that were beautifully lit and well-printed. I was envious of their technical prowess.

I asked in my mind, "Heavenly Father, is that porn?" Instead of a warm, "Yes, son," I felt the incredulous stare of a loving Father. After the meeting, I drove straight to my studio, gathered my art collection, and dumped it in the recycle bin outside.

I felt liberated and closer to God. The experience made me pause to evaluate the power of my chosen medium. I had to ask the question again: How can I be righteous in a field where most of the legends are not?

"Stop drinking Monsters." It had become almost ceremonial that on the way to a shoot, I would grab a super-sized Monster energy drink. After drinking it, I could work with energy and excitement. Then the little voice inside me said, "Stop drinking Monsters." I asked, "How could *that* be pertinent to anything?" The idea persisted though. So, I quit. For a month, I gained weight and suffered through a relentless and blunt headache. But I never looked back. And my energy levels increased.

I see now that the Lord was preparing me to take on the all-consuming project of *Reflections of Christ*. And on the many nights I stayed late at the studio, retouching and working on photographs depicting the Savior, I was not jittery. I rested my dependence and energy squarely on the Lord. I prayed

for energy. And I received it. There were nights I would return home at 3:00 AM and my energy would still be so high I couldn't sleep.

Rather than craving Monster energy drinks, I began to crave the companionship of the Man whom I was depicting. His influence is more powerful and permanent. Plus, no headaches.

————————

I'm not sure how the idea for *Reflections of Christ* popped into my head. But it did. And it evolved. The original plan was to photograph different people portraying the men and women who were players in the life of Christ. I wanted to find their contemporary image-bearers. The general theory was that there are those who still follow Christ and that would be reflected in their countenances. What would Mary Magdalene look like? Peter? Christ? I planned to shoot the photographs in the studio with a backdrop.

I didn't have costumes, so I called the director of the Mesa Easter Pageant, Nanci Wudel, and told her my plan. She was excited by the idea of having new PR photographs for the pageant. She gave me access to their volunteer actor list, costume department, and props department.

I also enlisted the help of Cameron Trejo, a talented filmmaker and friend, who accepted my invitation to document the making of *Reflections of Christ*. He and I shared many late-night e-mails while working on this project. Once he unraveled my vision, it became his, too, and his documentary work was incredible.

On the shoots, Cameron was always present with a video camera and I was always miked. Periodically, he would send me the footage edited together with music and my own voice. He grasped my ideas so well that he was able to cut through my awkwardness in explaining them and get right to the point.

When he first sent over the "Angels" clip, my wife and I watched it in awe. We posted it online and the clip began to get a ton of traffic. It was as I had suspected—the process of making these images was, in many ways, as powerful as the images themselves.

Cameron's film clips allowed me the privilege of having a global view of my work while I was creating it. In the process, I gained a rare friend, one who could predict and interpret my movements and artistic expressions. Through his thirty-minute documentary, I was able to tell more than 100,000 people that I believe in Christ. Looking back, I can see the change in my countenance that was recorded on video over a four-month process. (I was also touched to notice the change in my eighteen-year-old assistant, Sam Bawden, who worked side-by-side with me and learned with me. He completed every task I asked of him and was with me for every shoot.)

Early in the project, I received a visit from a dear friend and my current ecclesiastical leader, Charles Doane. We sat in my family room and quietly discussed the small project upon which I'd embarked.

Under the influence of a divine spirit that was present in the room, Charlie assured me that the *Reflections of Christ* project was not my idea, that the Lord knew about it long before I ever did, and that this was a very real mission in my life. He also told me that "the world would see it and many lives would be changed." He warned me of the pitfalls that could occur when undertaking such a sensitive project. He also assured me that being consumed with the life of Christ and His teachings would act as "a shield against temptation."

I count that conversation as a singular event in my life. How could he have known the potential impact of this project? Divine guidance. His "shield against temptation" comment proved true. The pursuit of Christ consumed me, and the temptations which had so easily beset me in the past disappeared. My prayer for guidance was finally answered. I knew I was on the right track.

————————

Somehow, the idea of doing everything in-studio disappeared and we began looking for locations. A good friend and fellow photographer, Steve

Porter, volunteered to scout locations for us. His aerial photography background served us well as he flew all over the high desert of Arizona, uncovering spots that resembled the Holy Land. His location choices were inspired and breathtaking. There are several little spots in the Arizona desert that are very sacred to me now, thanks to Steve.

One of those sacred spots is Arivaca, Arizona, along the Mexican border. We shot nine images there, including Christ's baptism, the Gethsemane scenes, and the crucifixion. Shooting those images in Arivaca was a powerful manifestation of things that I was privileged to imagine and daydream. Candidly, I sometimes wasn't sure if certain things would turn out. Some ideas didn't. Others surprised me.

One common thread throughout the shoots was that technique took a backseat to the experience of the subjects. Many technical issues can be fixed in postproduction, but matters of intensity, sincerity, and emotion are much harder to fake or invent in Photoshop.

Some of the most sacred hours for me were spent in the studio late at night, examining the images and making final artistic decisions. Creativity came in spurts between the drudgery of small, but necessary, tasks. Sometimes the bursts would last for twenty minutes, sometimes four or five hours. Only one thing was as satisfying as reaching a comfortable stopping point on a particular image, and that was discovering new elements and details that could not be seen on the camera's small digital screen: goosebumps on the blind man's arms. Teardrops in the adulteress's eyes. The glow around the tenth virgin. Intense pleading in Christ's face in Gethsemane. Triumph in the Resurrection. A normally active horse bowing in reverence at the scene of his Creator on a cross.

I still receive e-mails highlighting insights into the images that I was supposed to have known everything about. I'm constantly learning new things about them myself.

My studio is sacred now. Late at night, there is singularity in the art that occurs there.

———————

My family was an amazing support to me during the project. My parents supported my career change without any (audible) hesitation. They continued to support me during the entire project.

My dad, unsolicited, rented a motor-home for us to use in Arivaca, which turned out to be an inspired blessing. He was also there to drive me home as I slept in the front seat after an exhausting two-day shoot.

Reflections of Christ was all consuming: Time. Money. Focus. I remember a conversation I had with my wife, Tara. She was concerned about finances and I insensitively said, "Honey, I would sell the farm to finish at this point." Rather than crumble, Tara stood by me. The freedom she gave me during this project allowed me to find out who I am. I love her for that and for so much more.

———————

Luckily, I wasn't the only one who believed this project was inspired and who was touched by the Spirit. After speaking to a group of the Easter Pageant leadership, I was approached by David Peterson, the director of the center where the pageant was held. Without having seen a single finished image, he offered to hang the images upon completion where they would be seen by hundreds of thousands of people. One of the stipulations, though, was that the project needed to be finished two months prior to the original deadline. The compressed timeline proved valuable to me as I had to increase my reliance on the Lord and on those whom He sent to help me finish the project.

With the new development of a possible gallery show, I knew that we needed some help with the presentation.

My good friend Kim Eaton took an entire crew and within four days, transformed an open theater into a high-class gallery. He had a vision of his own for lighting the large pieces on the wall and suspending them with wire. He

managed to use only five screws to attach the walls to the permanent structure. His walls isolated the viewer and Christ, creating an intimate space that only added to the experience.

I'm not a musician, but I can readily identify the elements in music that have a connection to my own work. Jason Barney, a long-time acquaintance turned very good friend, offered his studio and expertise to help me achieve a musical score that would equal the work in power and message.

I approached another friend, Clyde Bawden, whose solo piano scores move freely and powerfully through the emotional spectrum. His songs had already accompanied some of the more sacred moments of my life. I boldly challenged him to do something he normally wouldn't consider. I needed him to be the backbone accompanist and head composer of a score that would fit a vision that was still developing in my own mind. He agreed completely; he even agreed to accompany vocals. That was big.

My first request was for "Come, Thou Fount of Every Blessing." Clyde had already composed an amazing piano solo of this hymn, but he also created a second version that matched the modern, yet reverent, vision I had. In my studio one night, I played Clyde's recording of the song with Freddie Ashby's earthy vocals more than twenty-five times in a row as I retouched the photos. The song became an anthem to everyone involved in the project.

I also challenged Clyde and Jason to rearrange "Joy to the World" so it could be played year-round. With Melynda Brimhall's angelic vocals, it worked. There are intense moments created by the piano that are simply breathtaking.

I wanted to feature my favorite song, "Amazing Grace." When I was eight years old, I attended my great-grandfather Garner "Pop" Mabry's funeral, and my Grandpa Mabry played the song on his accordion. I have loved it ever since. The lyrics applied to my situation as I experienced a gift of creation and creativity on a level I had not earned. I knew this was a gift mercifully given to me.

As the project continued, Clyde was kept awake one night and composed the *Reflections of Christ* theme. The song typified the creative journey that was unfolding before all of our eyes.

Moments in the studio were special, but perhaps none more than the first time Hope Shepherd wandered in with her beat-up cello case and skater shoes. Clyde was plucking away at "In Humility, Our Saviour" on the piano, and Hope joined in impromptu—without tuning or warming up first. The feeling of power in that room was strong and undeniable.

Once again, my mindset changed. Technique took a backseat even further than before. I turned inward and examined where my heart rested. Finally, I had a fire for Christ and a passion to know Him. Questions were answered and it was as if handcuffs had been taken off and I was able to love the Savior, freely and completely.

For over a decade, I longed for a fiery, palpable witness of the Savior. Perhaps I wasn't ready as a twenty-year-old man. Maybe my desire wasn't real or sincere enough. For whatever reason, our Father in Heaven found it best to let me experience the absolute love of the Savior as I recreated His life through photographs.

I could imagine Gethsemane. Picture the crucifixion. Let Him teach my child. Witness Him walking on water. In my mind, I have felt the tokens in His resurrected hands and looked into His eyes. I both fear and long for the day when I can see whether I did Him justice.

For now, I am comforted in knowing I've done all I can.

My invitation with this book is for people to think about Jesus. To think about His humble life, but then step back and think about the ascended Christ—the resurrected Christ—the one who still watches over us, who pleads for us now and forever. He is amazingly graceful. We do all we can do, but after that, we are completely saved by His grace. He is the source of our salvation.

Come unto me, all ye that labour and are heavy laden, and I will give you rest.

MATTHEW 11:28

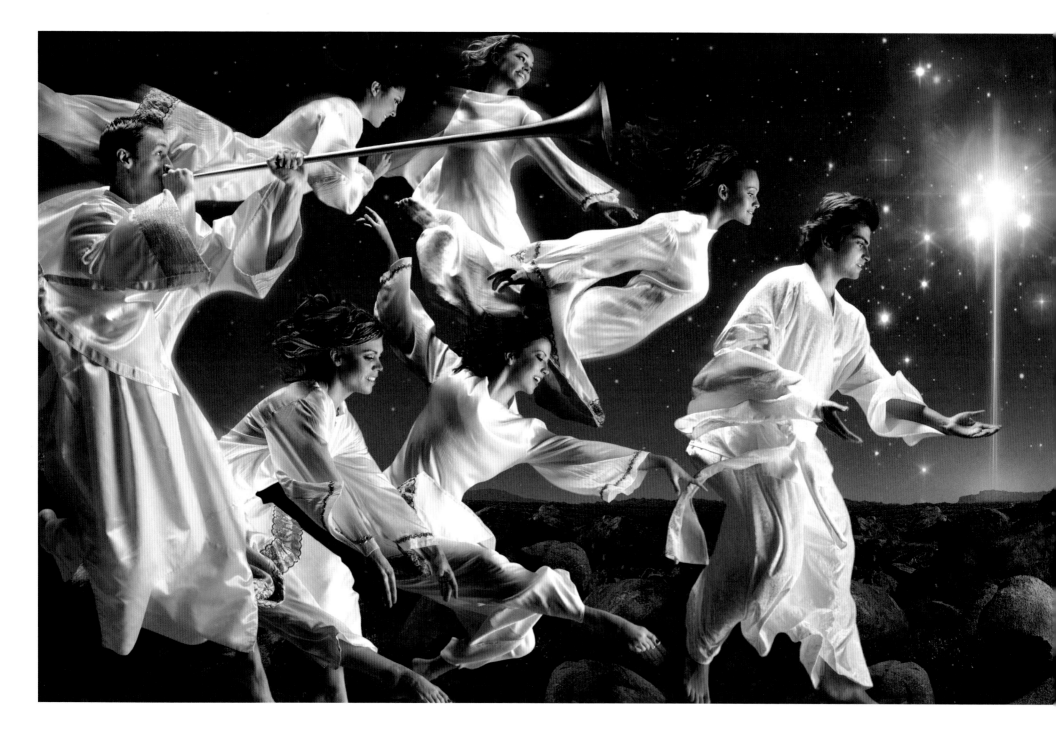

Angels

And the angel said unto them, Fear not: for, behold, I bring
you good tidings of great joy, which shall be to all people.
For unto you is born this day in the city of David a Saviour,
which is Christ the Lord. —LUKE 2:10-11

Fear not: for, behold, I bring

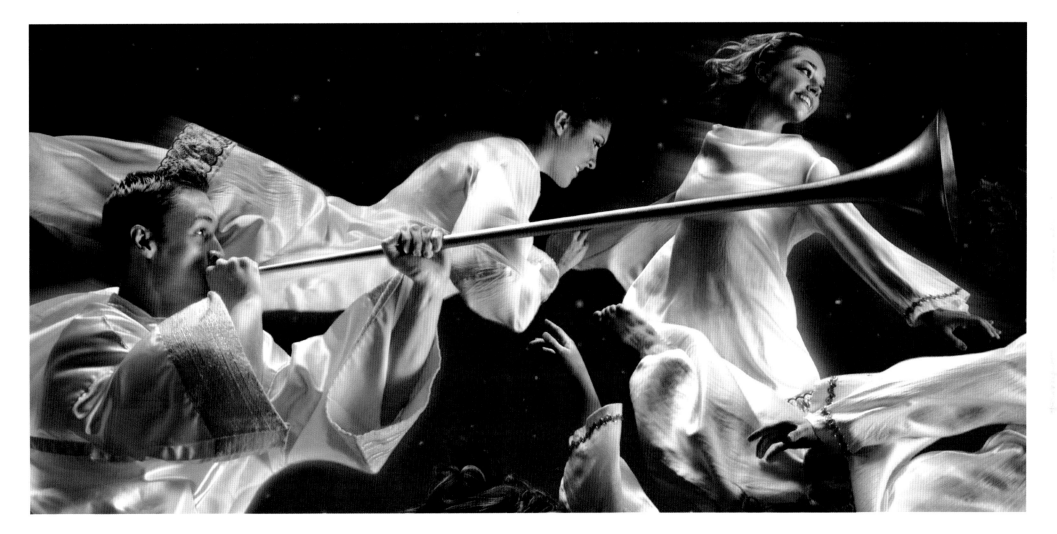

you good tidings of great joy

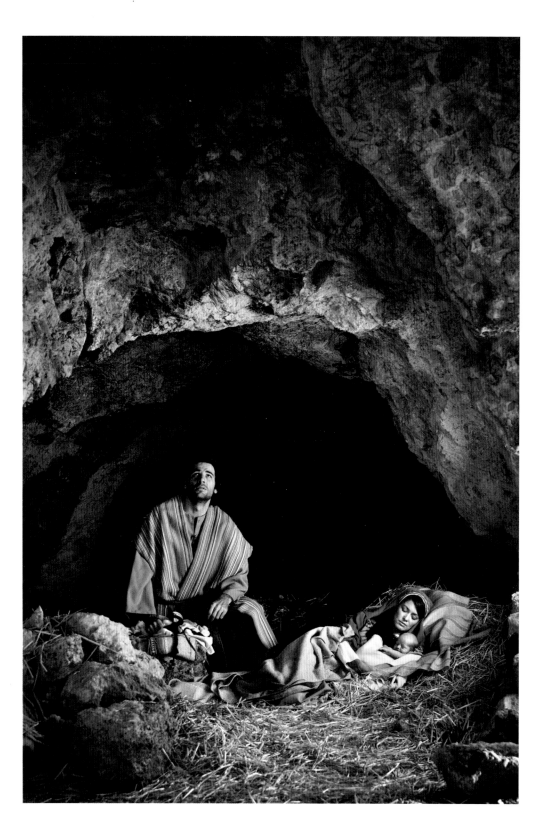

Son

And Joseph also went up from Galilee, out of the city of Nazareth, into Judaea, unto the city of David, which is called Bethlehem; (because he was of the house and lineage of David:) To be taxed with Mary his espoused wife, being great with child. And so it was, that, while they were there, the days were accomplished that she should be delivered. And she brought forth her firstborn son, and wrapped him in swaddling clothes, and laid him in a manger; because there was no room for them in the inn. —LUKE 2:4–7

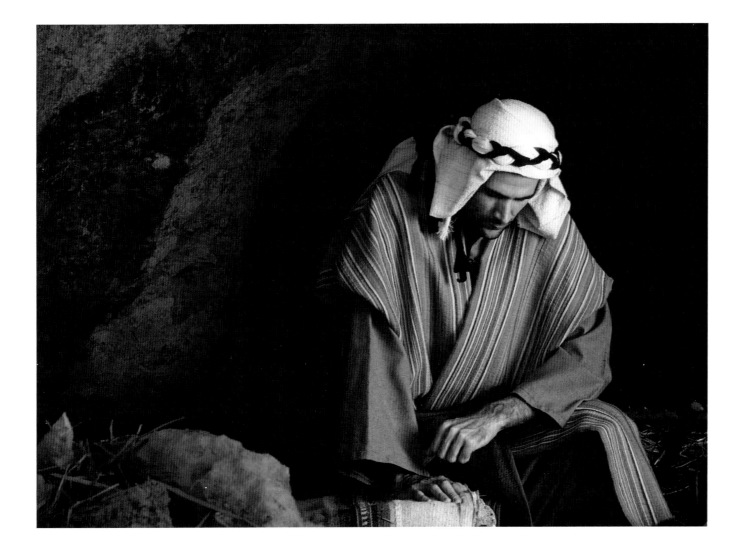

Husband

The angel of the Lord appeared unto him in a dream, saying, Joseph, thou son of David, fear not to take unto thee Mary thy wife: for that which is conceived in her is of the Holy Ghost. And she shall bring forth a son, and thou shalt call his name JESUS: for he shall save his people from their sins. —MATTHEW 1:20–21

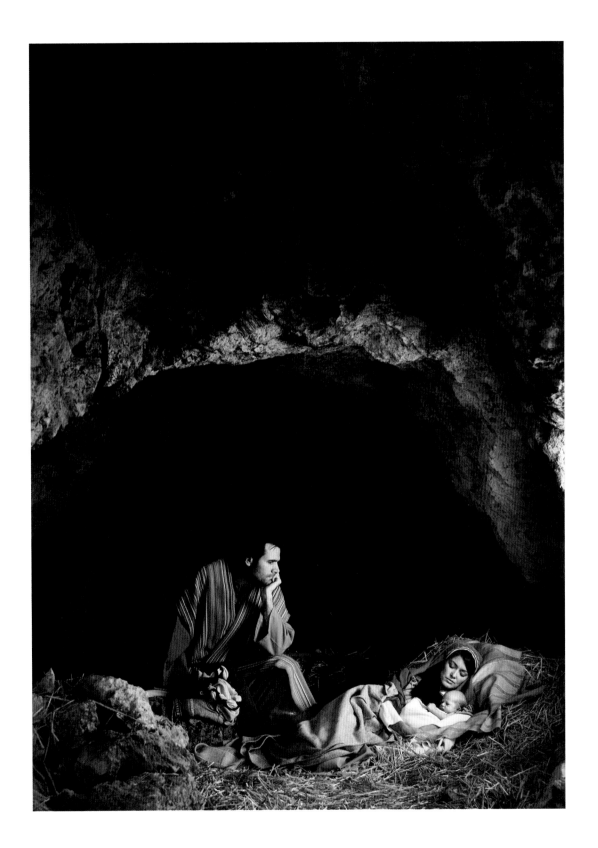

FATHER

And they came with haste, and found Mary, and Joseph,

and the babe lying in a manger. —LUKE 2:16

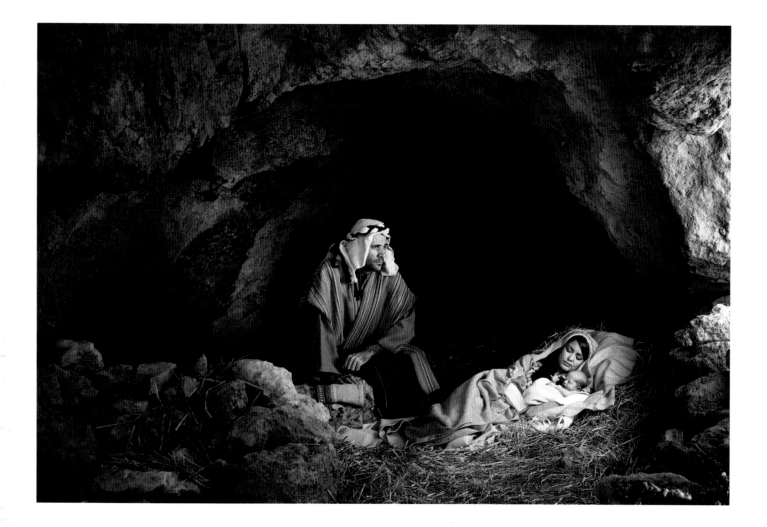

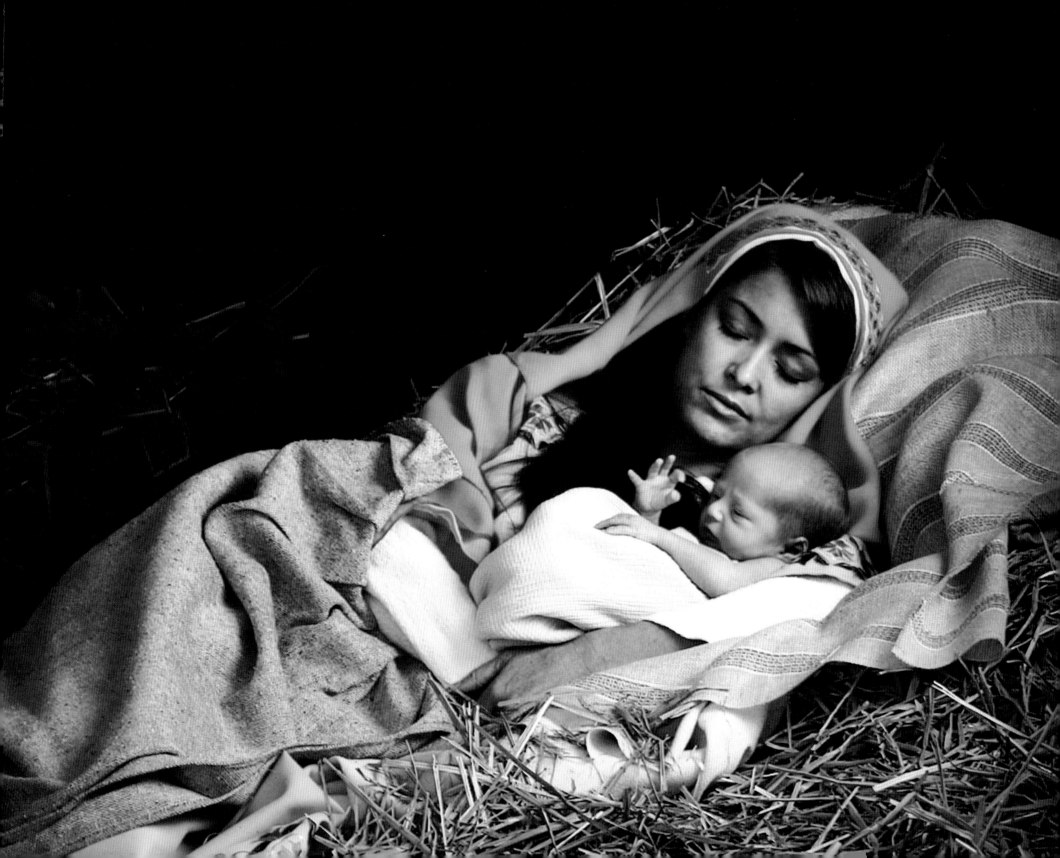

BAPTISM

And straightway coming up out of the water, he saw the heavens opened, and the Spirit like a dove descending upon him. —MARK 1:10

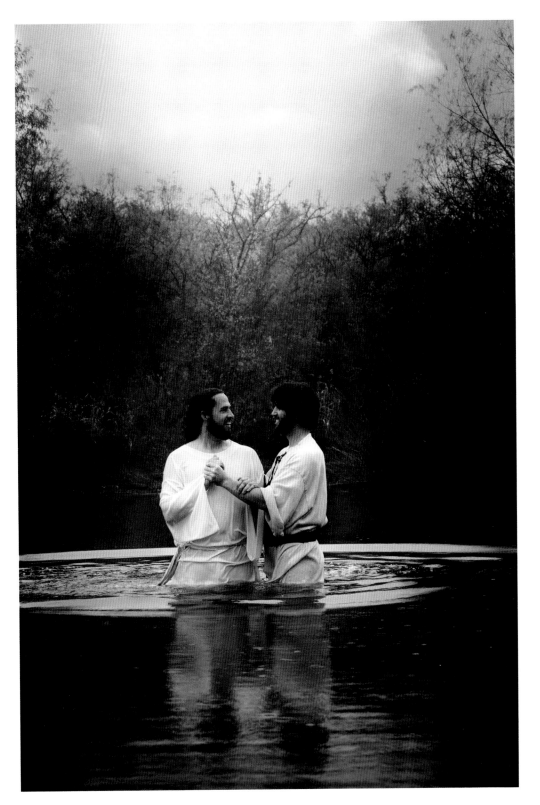

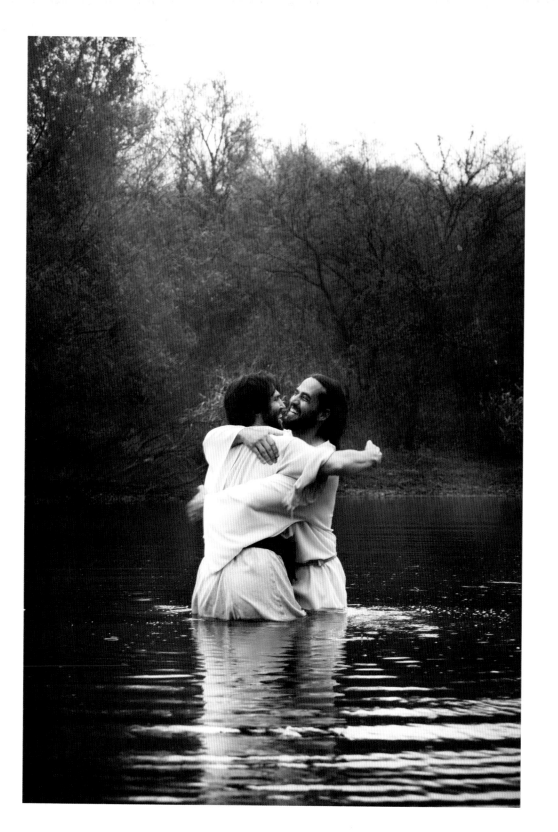

JOY

And lo a voice from heaven, saying, This is my beloved Son, in whom I am well pleased. —MATTHEW 3:17

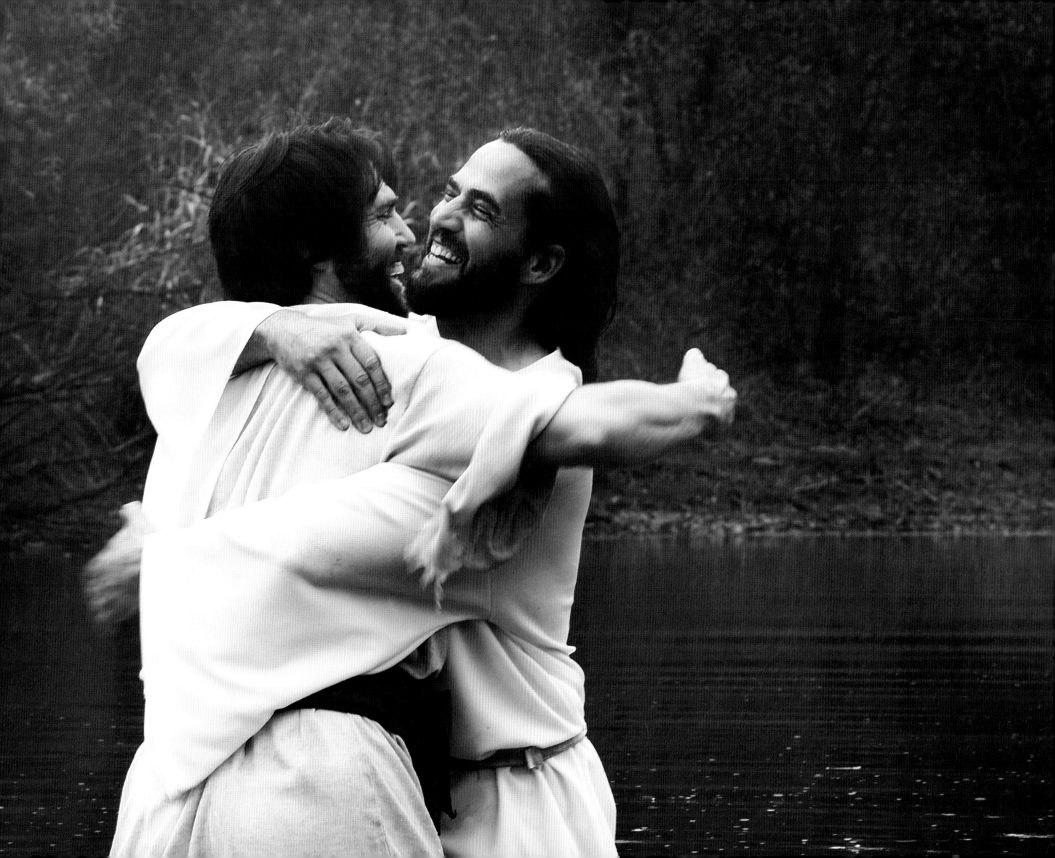

Walking on Water

And he saw them toiling in rowing; for the wind was contrary unto them: and about the fourth watch of the night he cometh unto them, walking upon the sea, and would have passed by them. But when they saw him walking upon the sea, they supposed it had been a spirit, and cried out: For they all saw him, and were troubled. And immediately he talked with them, and saith unto them, Be of good cheer: it is I; be not afraid. And he went up unto them into the ship; and the wind ceased: and they were sore amazed in themselves beyond measure, and wondered. —MARK 6:48–51

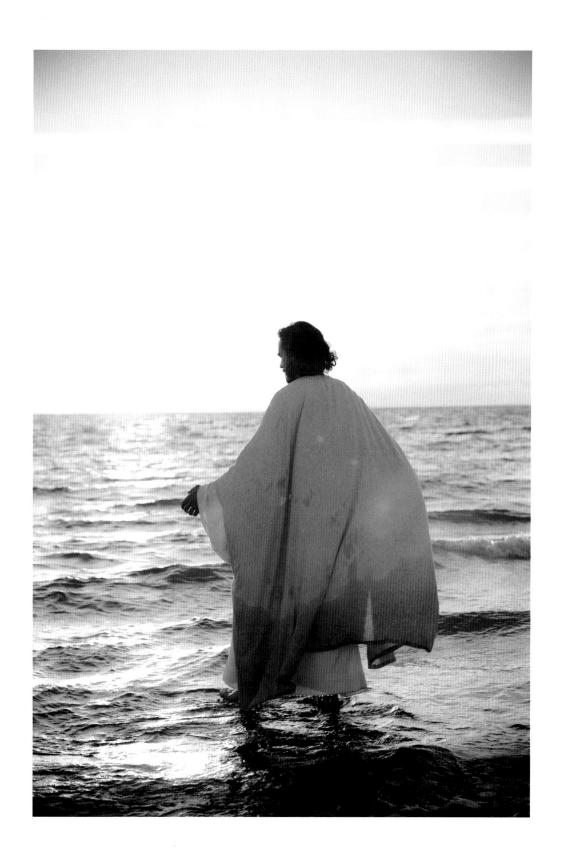

Teacher

And they were astonished at his doctrine: for he taught them as one that had authority, and not as the scribes.

—MARK 1:22

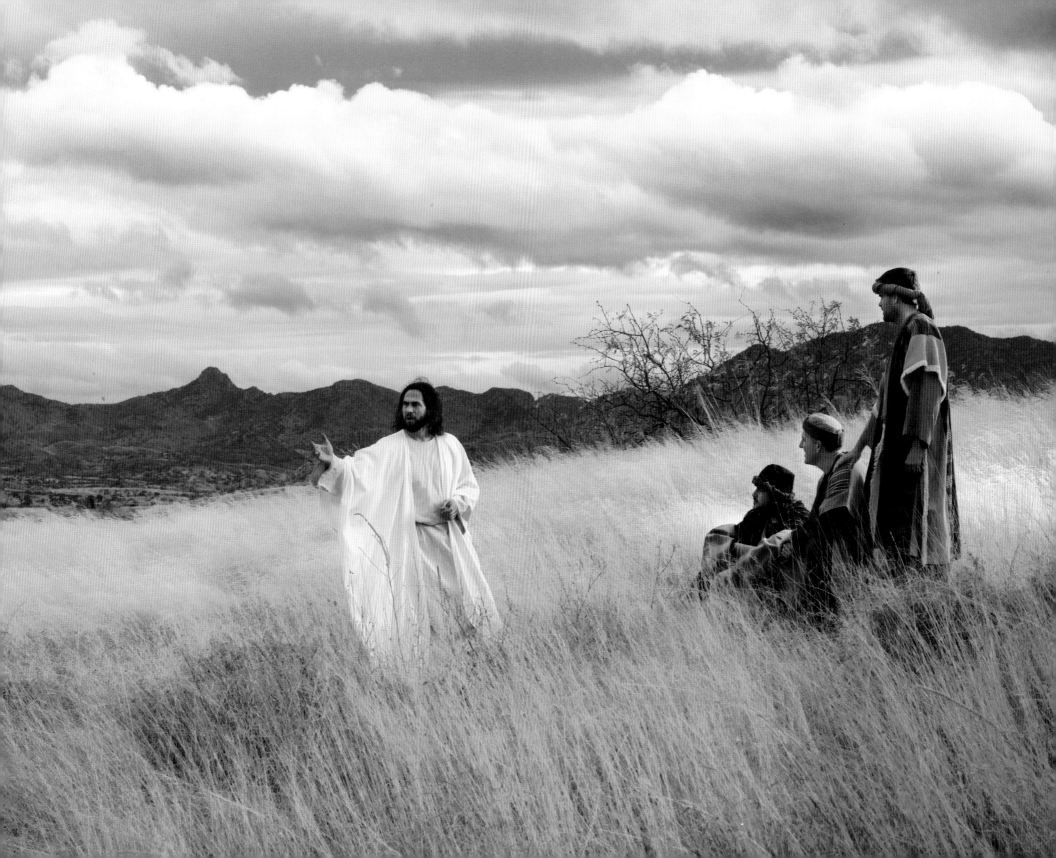

. . . he taught them as one that had authority . . .

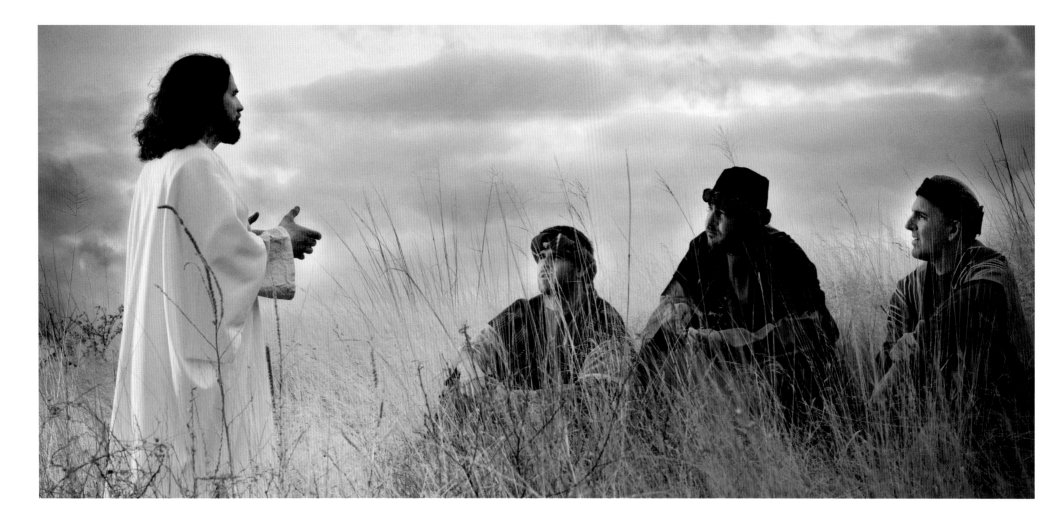

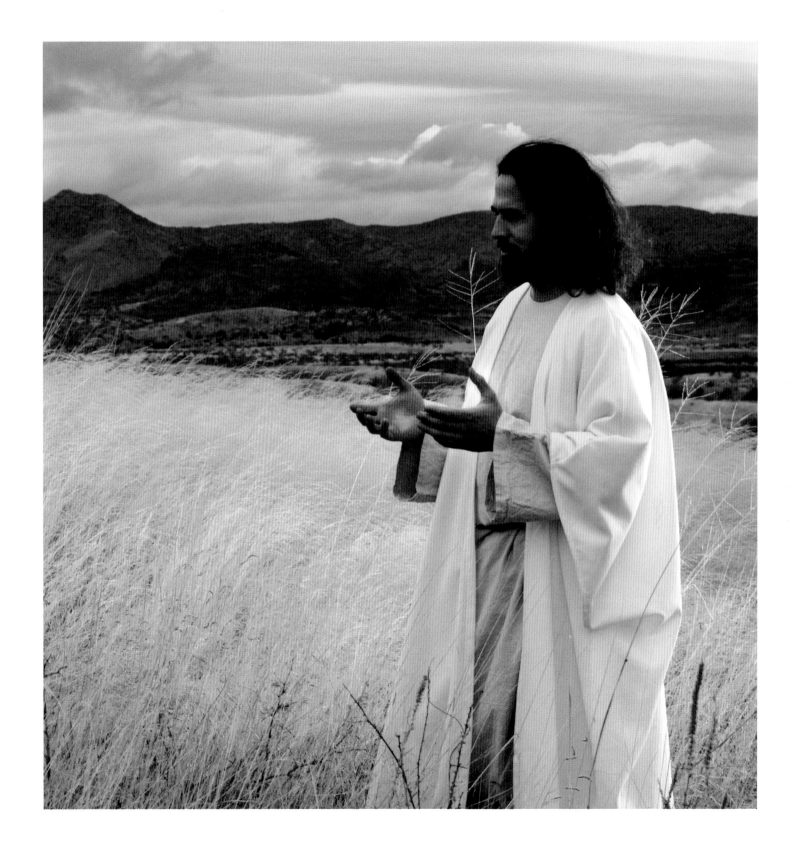

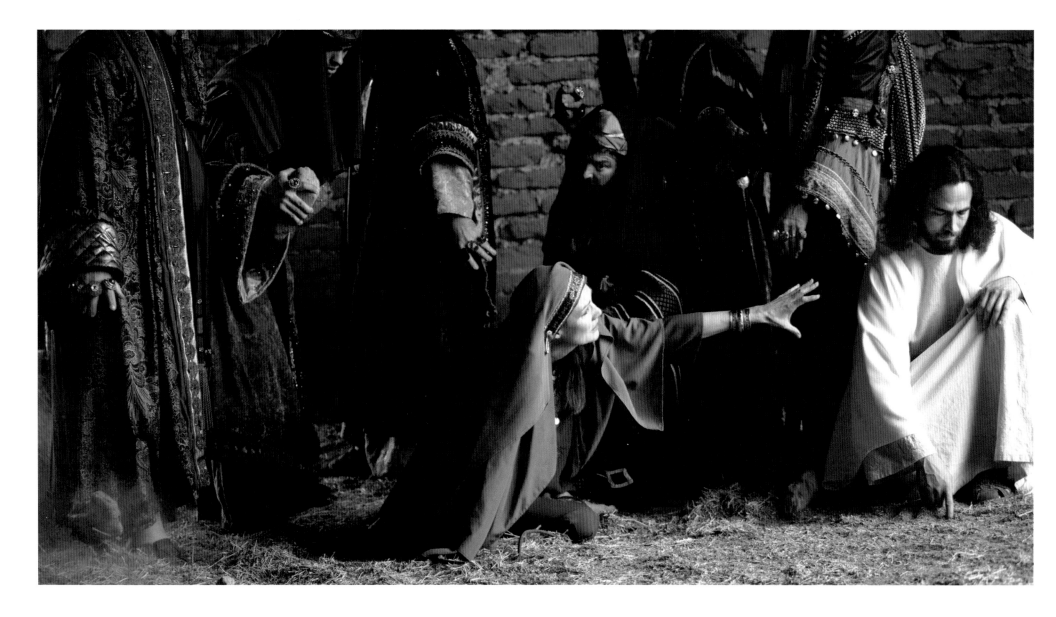

THE FIRST STONE

This they said, tempting him, that they might have to accuse him. But Jesus stooped down, and with his finger wrote on the ground, as though he heard them not. So when they continued asking him, he lifted up himself, and said unto them, He that is without sin among you, let him first cast a stone at her. And again he stooped down, and wrote on the ground. And they which heard it, being convicted by their own conscience, went out one by one, beginning at the eldest, even unto the last: and Jesus was left alone, and the woman standing in the midst. When Jesus had lifted up himself, and saw none but the woman, he said unto her, Woman, where are those thine accusers? hath no man condemned thee? She said, No man, Lord. And Jesus said unto her, Neither do I condemn thee: go, and sin no more. —JOHN 8:6-11

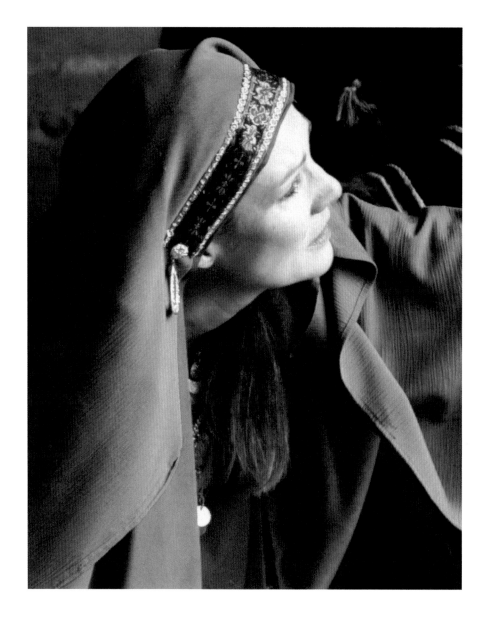

. . . go, and
sin no more.

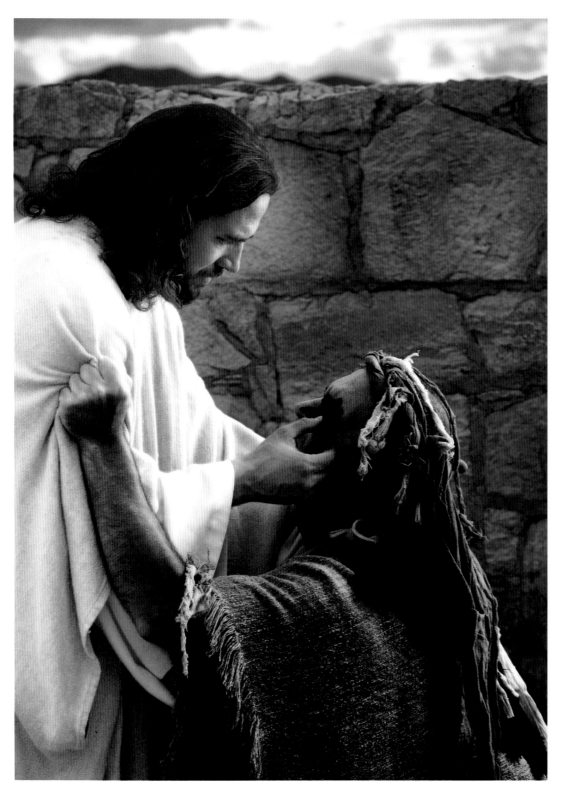

Healing

And as Jesus passed by, he saw a man which was blind from his birth. And his disciples asked him, saying, Master, who did sin, this man, or his parents, that he was born blind? Jesus answered, Neither hath this man sinned, nor his parents: but that the works of God should be made manifest in him. —JOHN 9:1-3

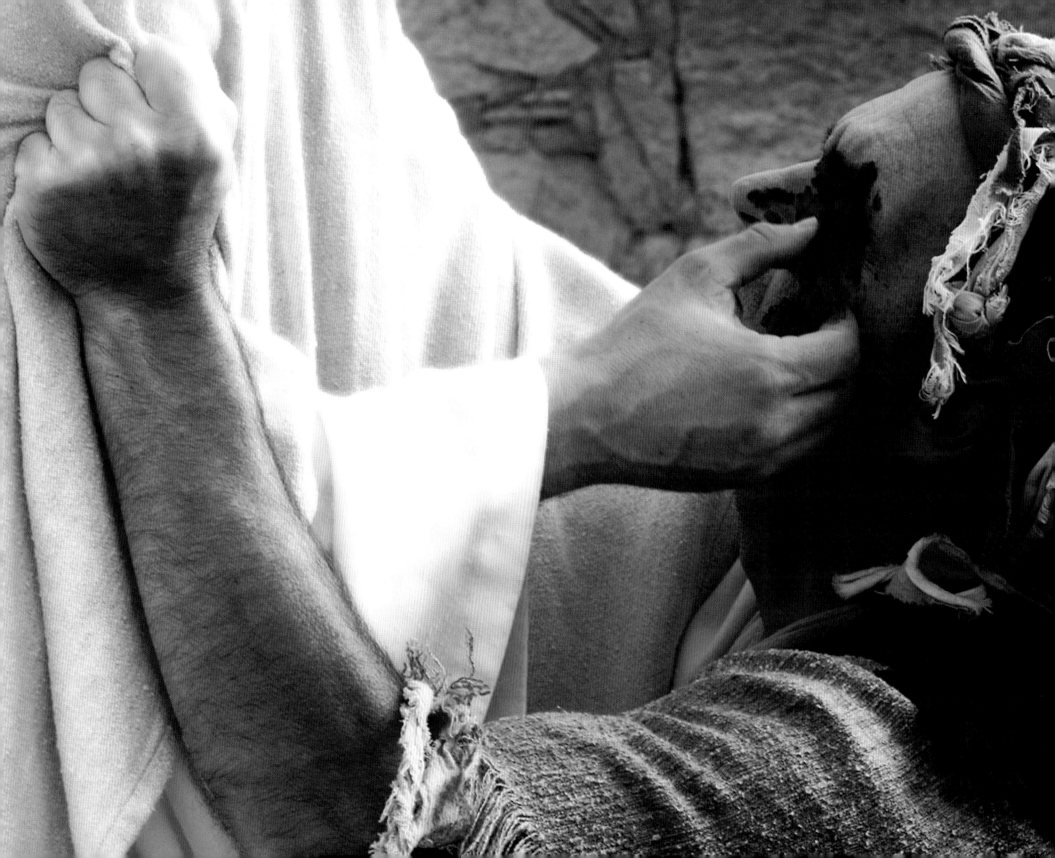

Wonder

But Jesus called them unto him, and said, Suffer little children to come unto me, and forbid them not: for of such is the kingdom of God. —LUKE 18:16

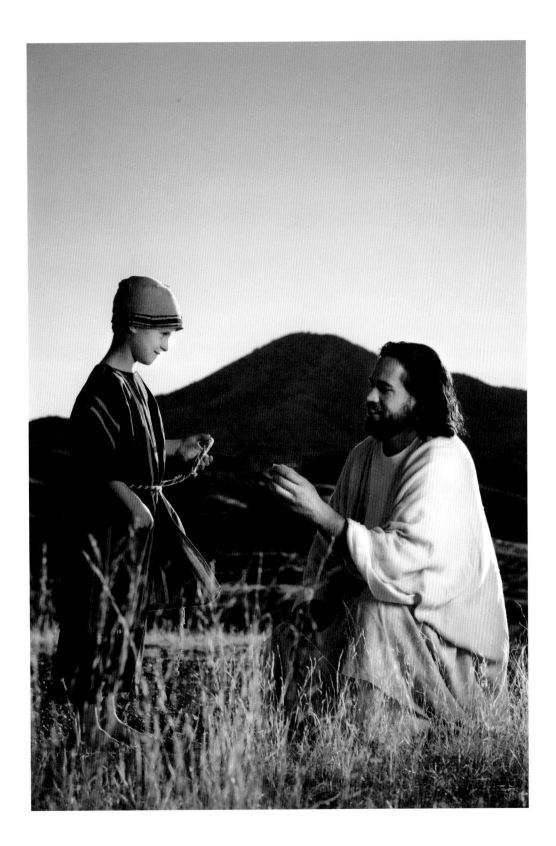

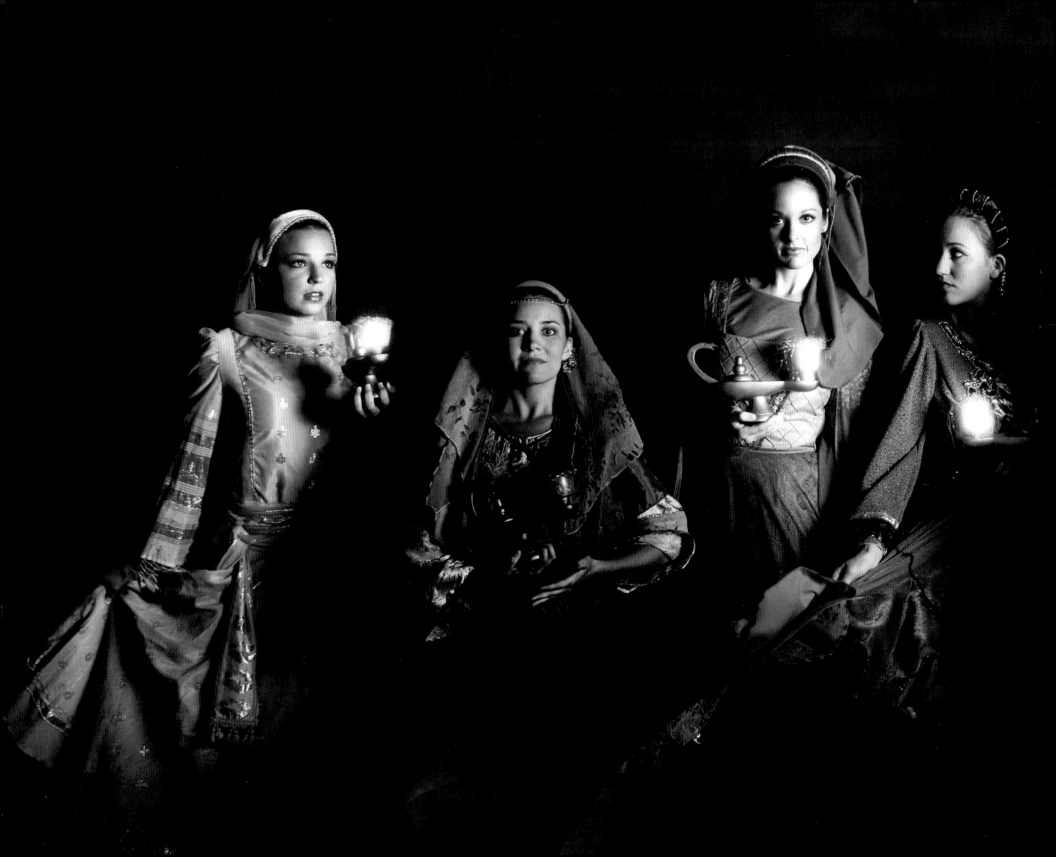

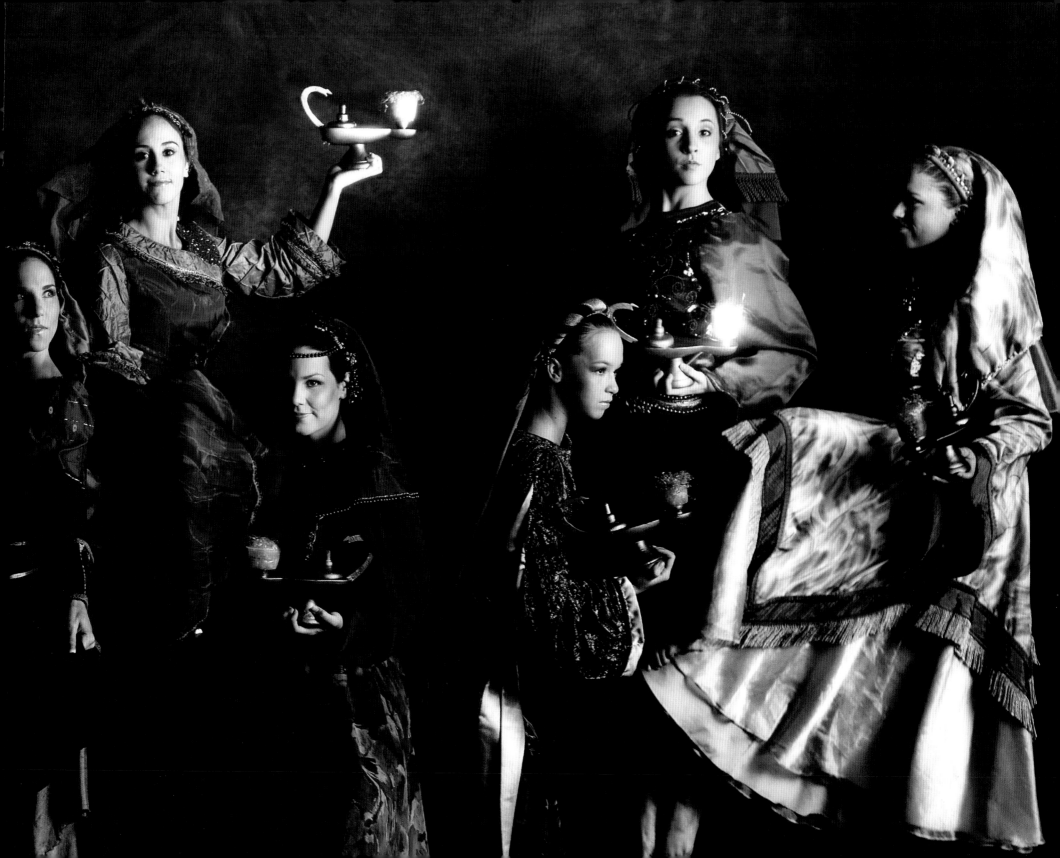

Ten

Then shall the kingdom of heaven be likened unto ten virgins, which took their lamps, and went forth to meet the bridegroom. And five of them were wise, and five were foolish. They that were foolish took their lamps, and took no oil with them: But the wise took oil in their vessels with their lamps. While the bridegroom tarried, they all slumbered and slept. And at midnight there was a cry made, Behold, the bridegroom cometh; go ye out to meet him. Then all those virgins arose, and trimmed their lamps. And the foolish said unto the wise, Give us of your oil; for our lamps are gone out. But the wise answered, saying, Not so; lest there be not enough for us and you: but go ye rather to them that sell, and buy for yourselves. And while they went to buy, the bridegroom came; and they that were ready went in with him to the marriage: and the door was shut. —MATTHEW 25:1–10

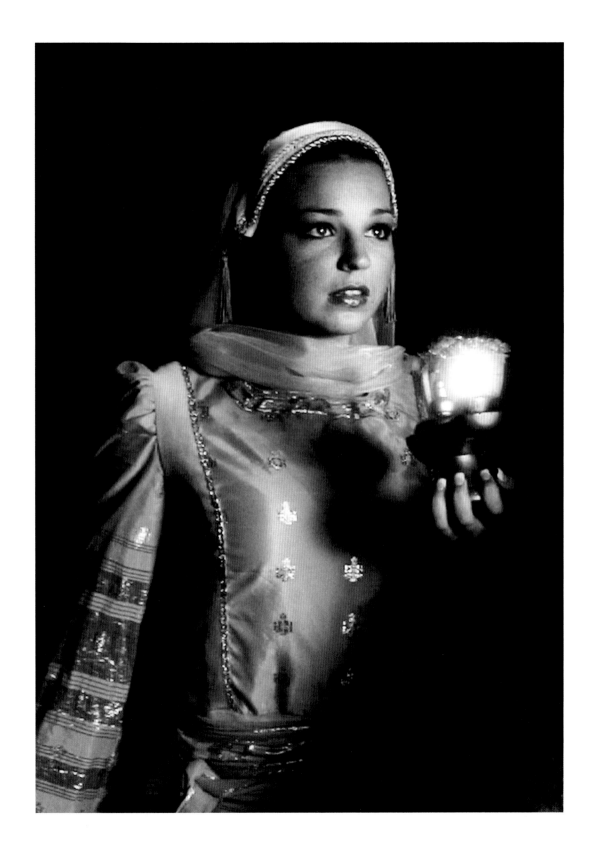

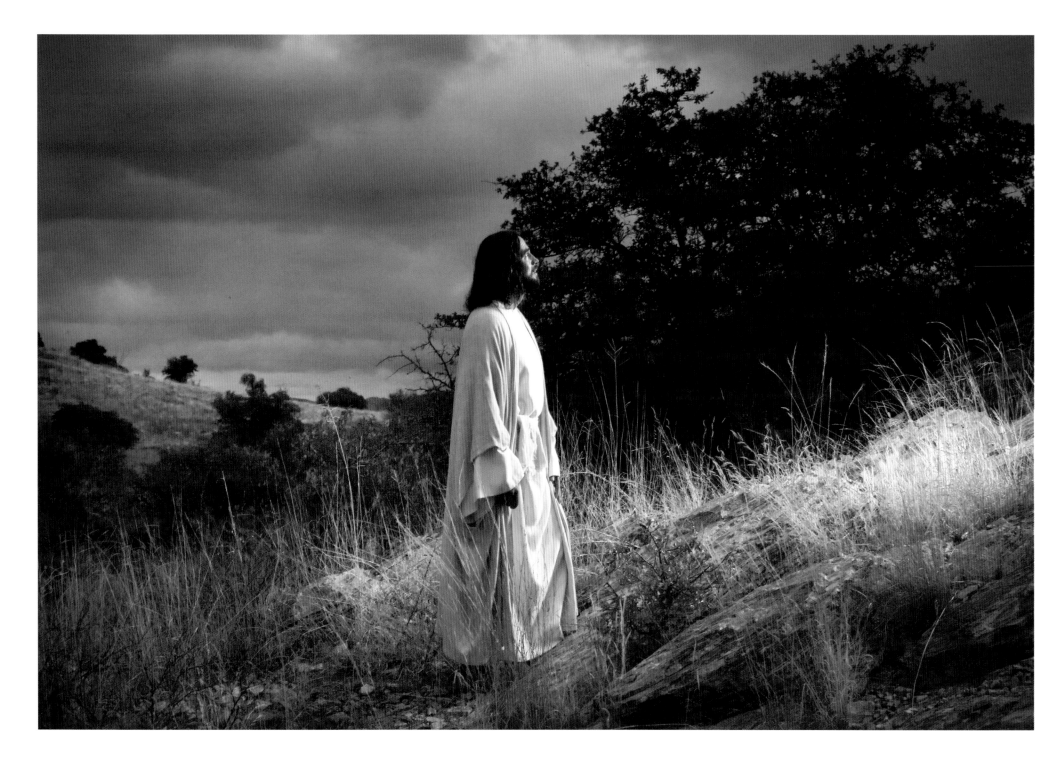

PROGRESSION

O righteous Father, the world hath not known thee: but I have known thee, and these have known that thou hast sent me. And I have declared unto them thy name, and will declare it: that the love wherewith thou hast loved me may be in them, and I in them. When Jesus had spoken these words, he went forth with his disciples over the brook Cedron, where was a garden, into the which he entered. —JOHN 17:25–26; 18:1

COMFORT

And he was withdrawn from them about a stone's cast, and kneeled down, and prayed, saying, Father, if thou be willing, remove this cup from me: nevertheless not my will, but thine, be done. And there appeared an angel unto him from heaven, strengthening him. And being in an agony he prayed more earnestly: and his sweat was as it were great drops of blood falling down to the ground. —LUKE 22:41-44

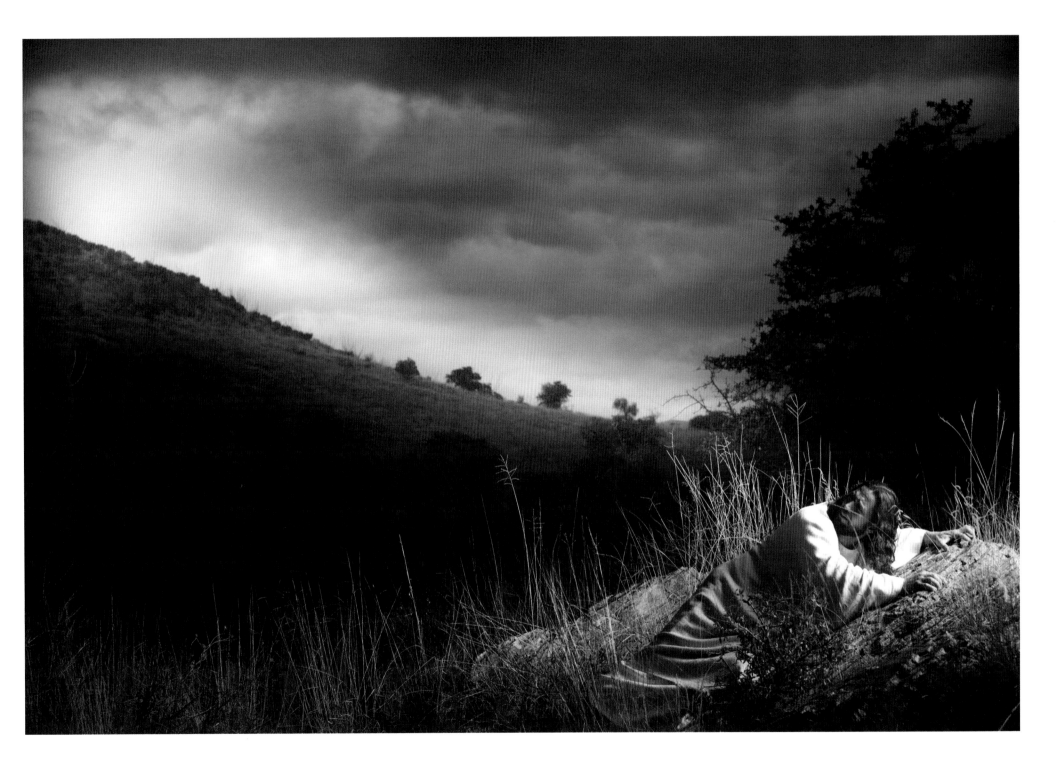

LOVE

And he went a little further, and fell on his face, and prayed, saying,
O my Father, if it be possible, let this cup pass from me: nevertheless
not as I will, but as thou wilt. —MATTHEW 26:39

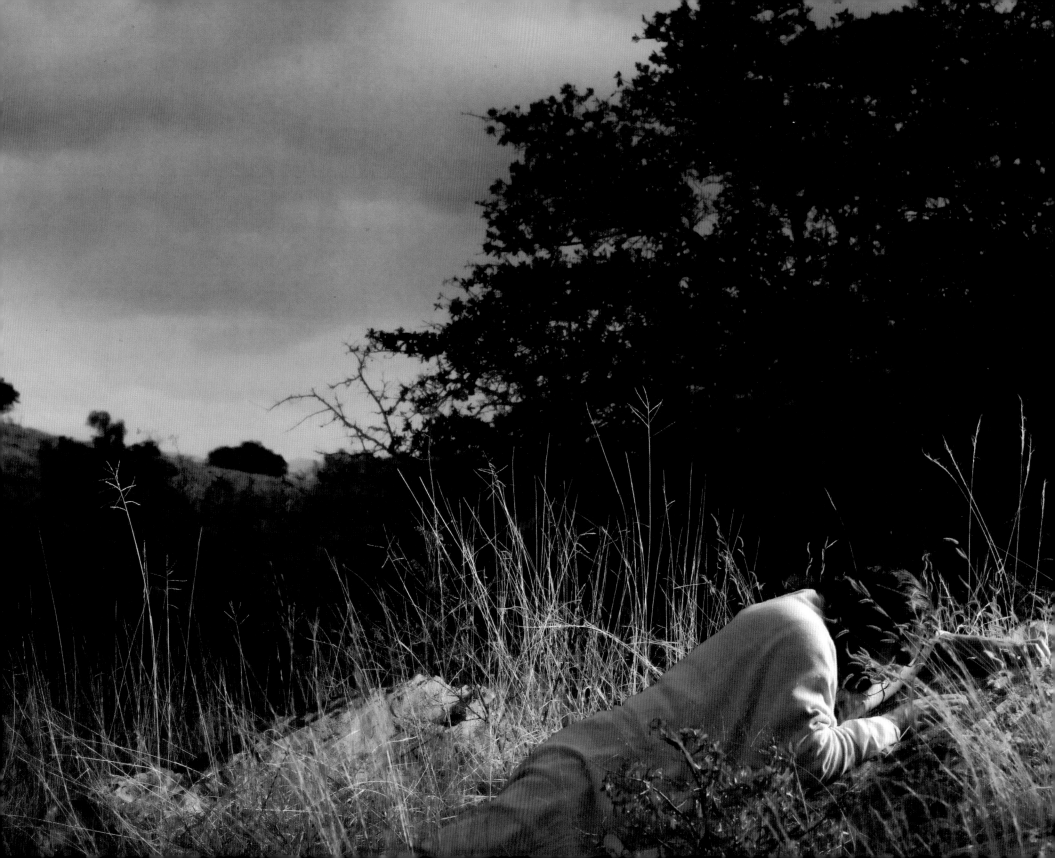

JUDAS

For what is a man profited, if he shall gain the whole world, and lose his own
soul? or what shall a man give in exchange for his soul? —MATTHEW 16:26

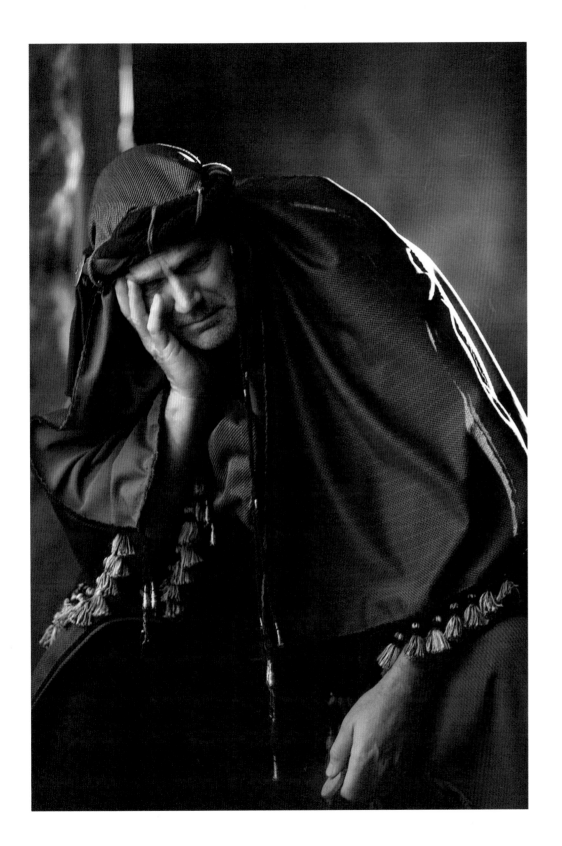

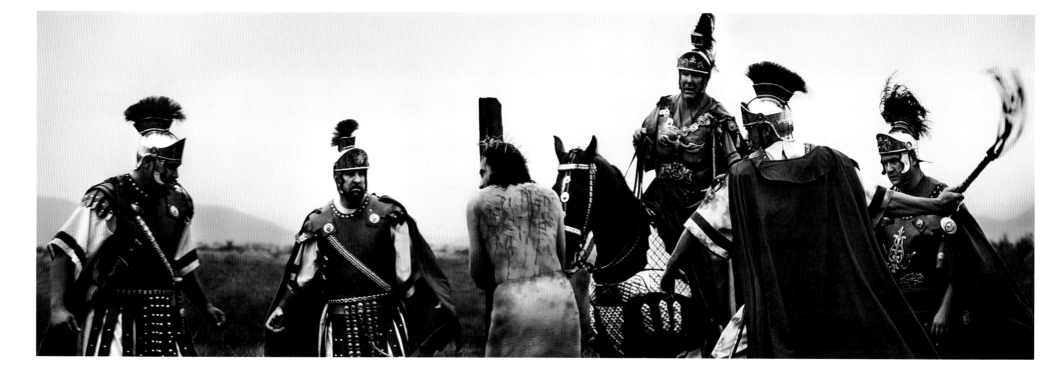

His Stripes

But he was wounded for our transgressions, he was bruised for our iniquities: the chastisement of our peace was upon him; and with his stripes we are healed. —ISAIAH 53:5

Patience

Thinkest thou that I cannot now pray to my
Father, and he shall presently give me more than
twelve legions of angels? —MATTHEW 26:53

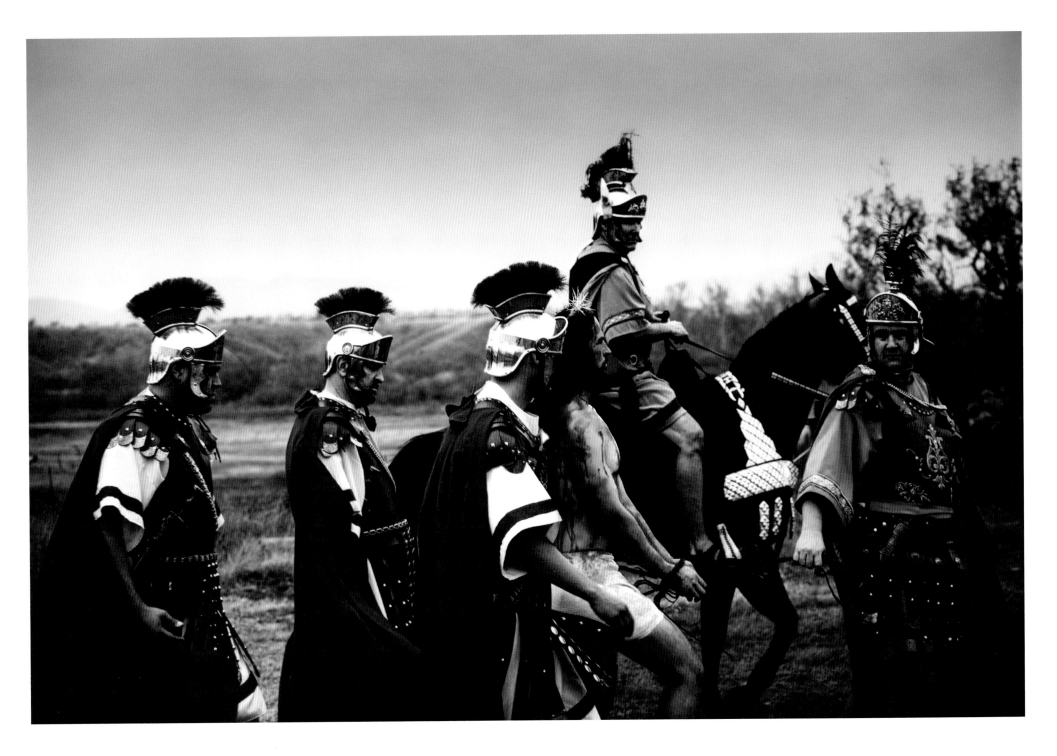

CRUCIFIXION

Then delivered he him therefore unto them to be
crucified. And they took Jesus, and led him away. And
he bearing his cross went forth into a place called the
place of a skull, which is called in the Hebrew
Golgotha: Where they crucified him, and two other
with him, on either side one, and Jesus in the midst.
And Pilate wrote a title, and put it on the cross. And
the writing was, JESUS OF NAZARETH THE KING
OF THE JEWS. —JOHN 19:16-19

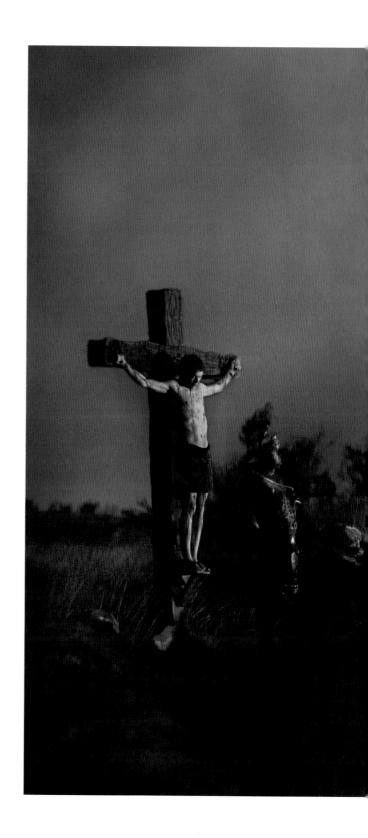

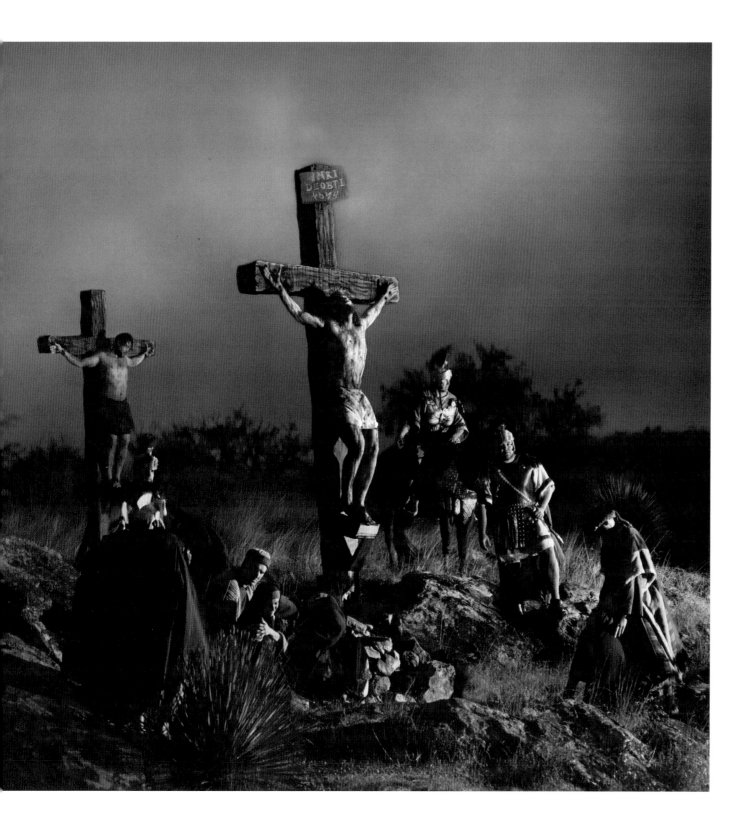

Jesus of Nazareth

the King of the Jews

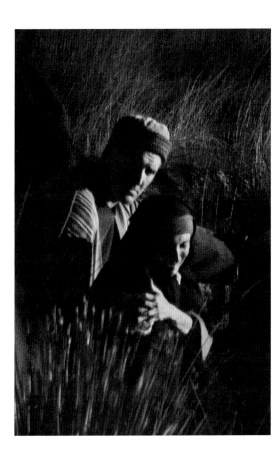 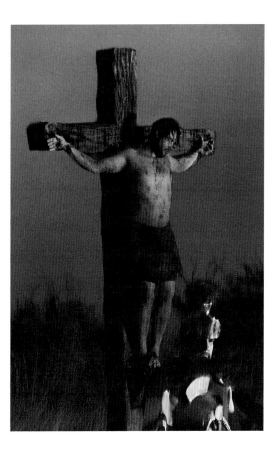

Confession

Now when the centurion, and they that were with him, watching Jesus, saw the earthquake, and those things that were done, they feared greatly, saying, Truly this was the Son of God. —MATTHEW 27:54

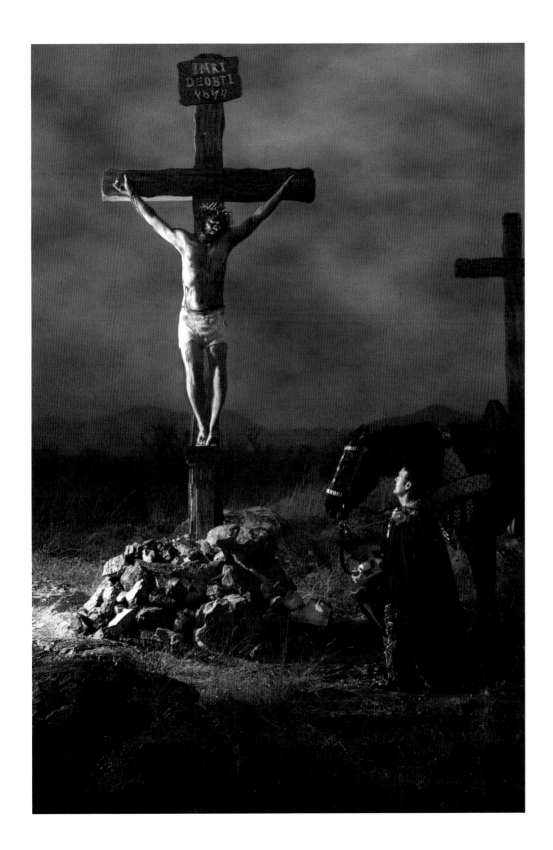

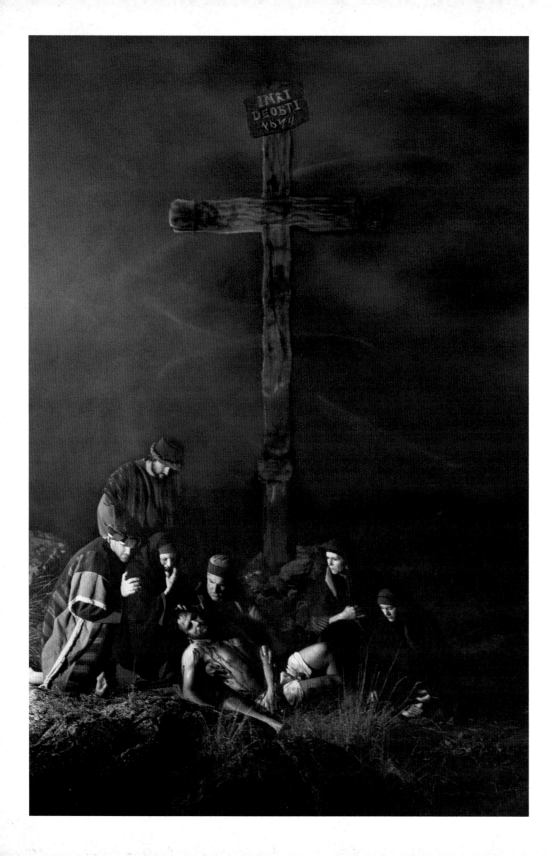

DESCENT

When Jesus therefore saw his mother, and the disciple
standing by, whom he loved, he saith unto his mother,
Woman, behold thy son! —JOHN 19:26

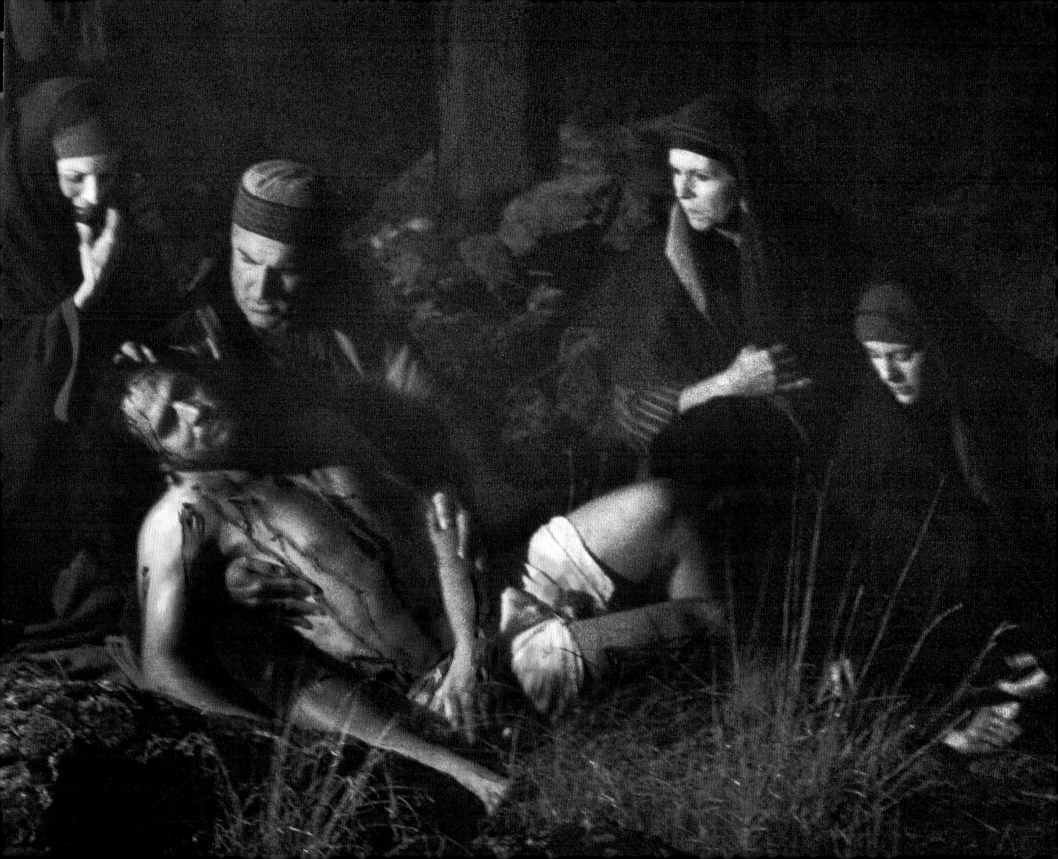

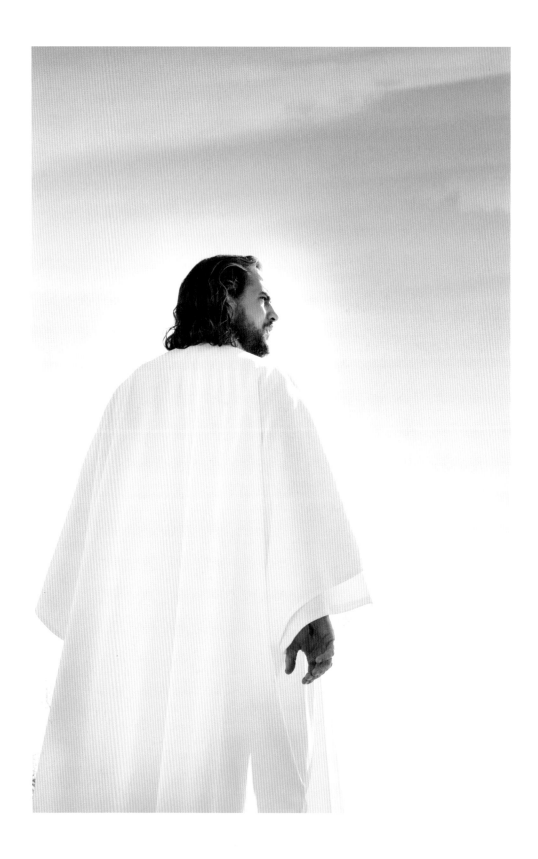

Resurrection

He is not here: for he is risen. —MATTHEW 28:6

Road to Emmaus

And they said one to another, Did not our heart burn within us, while he talked with us by the way, and while he opened to us the scriptures? —LUKE 24:32

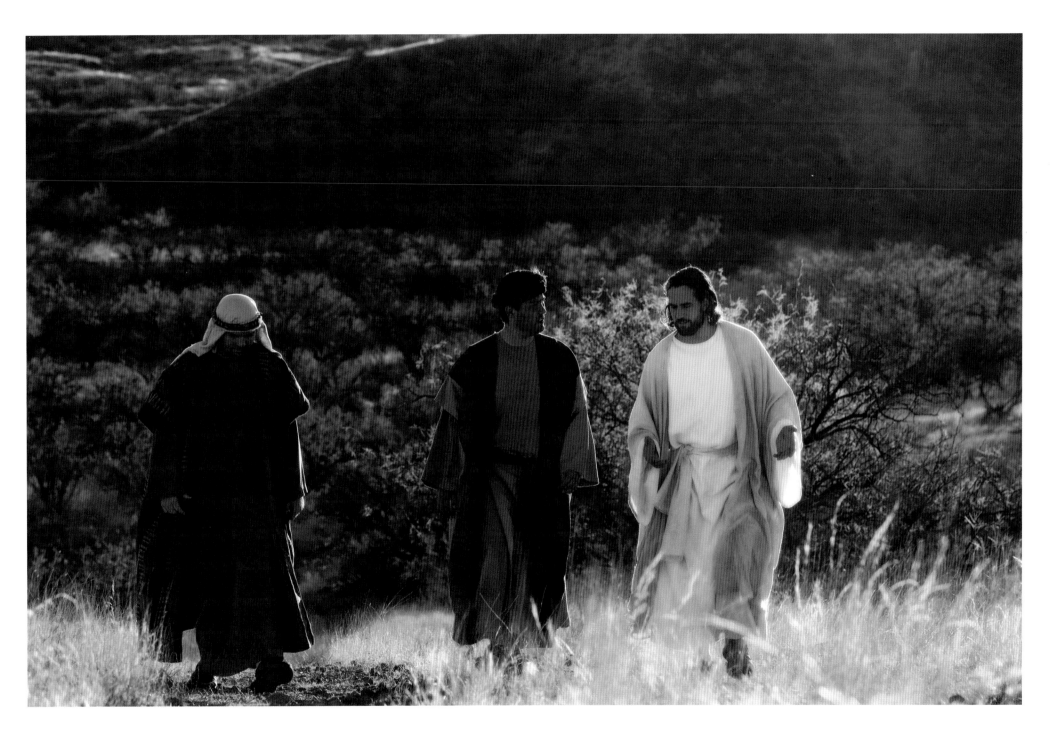

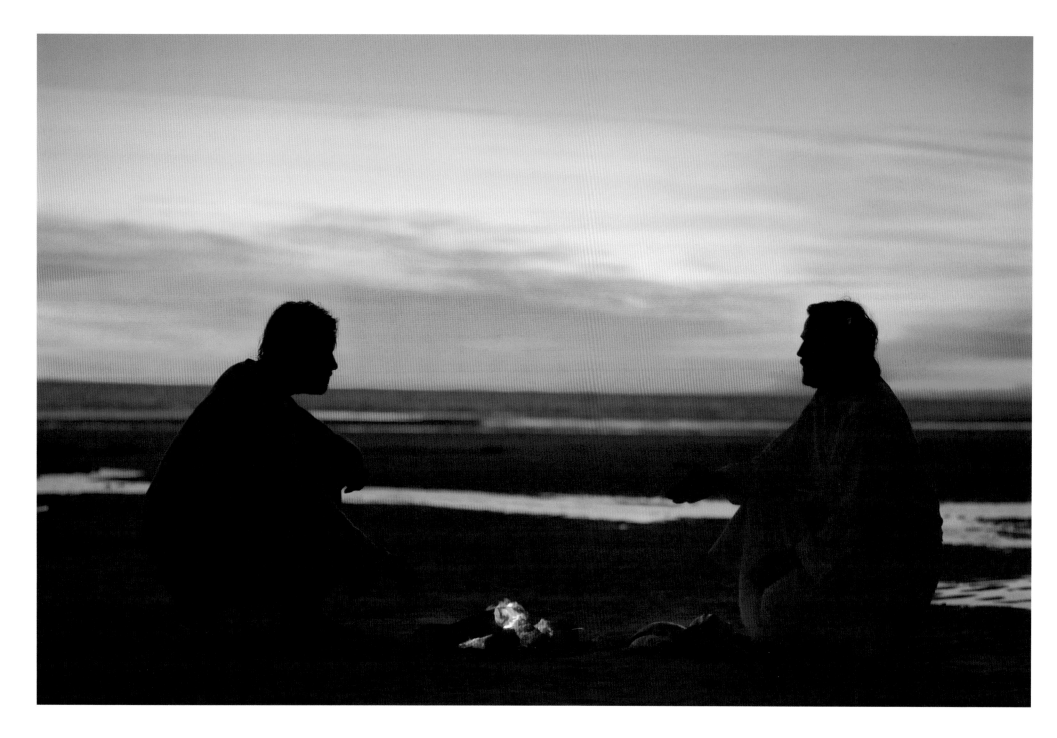

Lovest Thou Me?

He saith unto him the third time, Simon, son of Jonas, lovest thou me?

Peter was grieved because he said unto him the third time, Lovest thou me?

And he said unto him, Lord, thou knowest all things; thou knowest that I

love thee. Jesus saith unto him, Feed my sheep. —JOHN 21:17

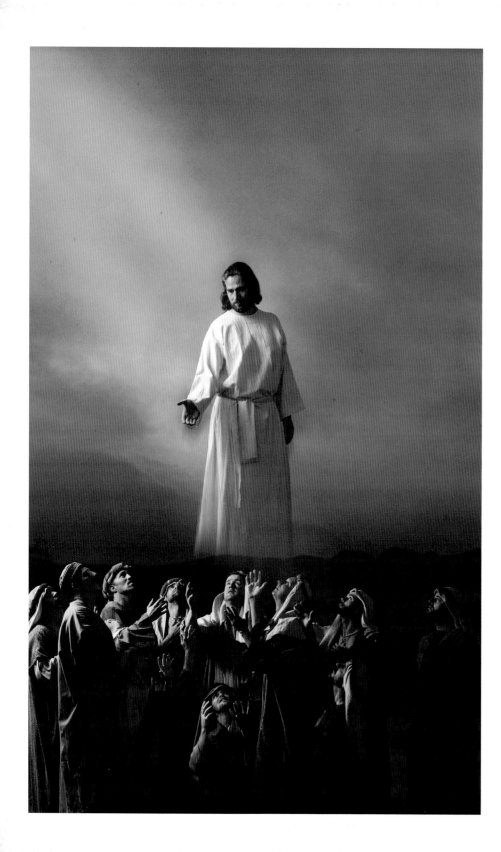

ASCENSION

And when he had spoken these things, while they beheld, he was taken up; and a cloud received him out of their sight. —ACTS 1:9

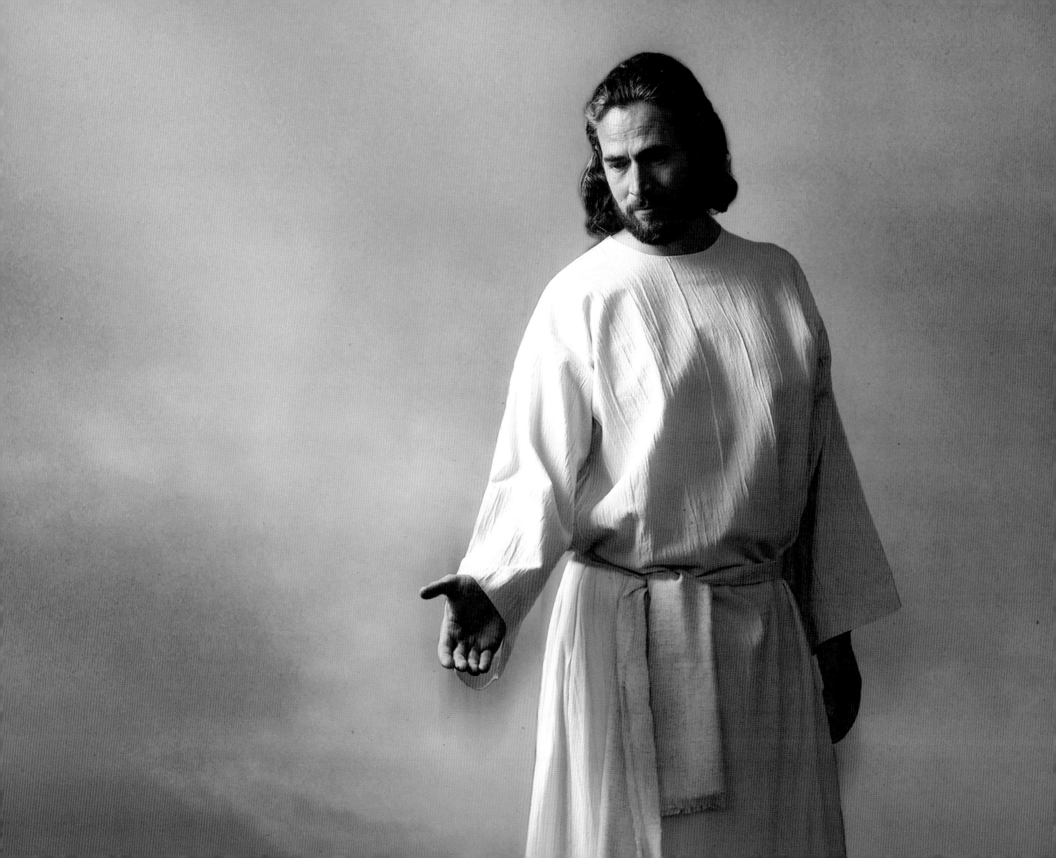

Artist Notes

Angels

Angels was my first photograph, and frankly I thought it was going to be my most-involved photograph because I wanted to make the angels fly.

My first thought was to harness the actors and hoist them into the air, but for me, that wouldn't allow for enough movement and flow. So how could I make angels fly? How could I put several angels in one frame without them stumbling all over each other?

One night I knelt, with a pencil and pad, determined not to get up until I had a solution. I prayed, fell asleep on my knees, woke up and prayed more. It dawned on me—use a trampoline.

It was a risky decision, not just for the health of my actors, but for the photograph as well. On a trampoline, I would only have about a tenth-of-a-second window to get the shot. A tenth of a second when an actor would be at the top of the jump, but not yet falling—just right in the middle. Weightless. Unchained. Moving like an angel through air and space.

And it worked. Some of the girls needed to appear calm, even while completely inverted or spinning. They all landed in various, obviously painful, contortions; they all got back up.

I photographed the background sky separately one night, capturing a desert landscape illuminated under a full moon with a good friend and fellow photographer, Steve Porter (whose $10,000 camera I had accidentally dropped down the ravine the night before). My friend, Robb, found the background stars on NASA's web site.

In the end, even though the angels appeared to the shepherds, I decided to leave them out because I wanted the focus to be on the joy of the message. It doesn't matter who's receiving the message because the message is the same to all of us—Christ was born. For me, this picture captures that moment of power—the delivery of that amazing message.

Son; Husband; Father

These images were shot in a cave in Superior, Arizona. I really wanted to feature Joseph because sometimes in nativity scenes, Joseph is more in the background. You never notice who he is. I've thought a lot about it, and in my opinion, I think Joseph must have been one of the most elect men ever to be on earth because he was chosen to raise the Son of God.

What I wanted to stress in these shots is the great burden he must have felt that night—that moment all fathers feel, when you realize, "Wow, this is pretty heavy to have a son. It's up to me to make sure he gets through the formative years all right." That's what I was focusing on for these images.

Baptism

On a weekend in November, a group of us—thirty-five in all—traveled to Arivaca to shoot nine images in two days. The weather report promised relentless rain and indeed, I awoke the morning of the first day of shooting to hear raindrops on top of the motor home. This couldn't be happening. I retired to a secluded spot and commenced praying in the rain. I said, "Father, this is my schedule. I know that we are up to good here. I will keep to my schedule, Father. Wilt thou please give us the weather that would be the best for our

efforts and art?" I felt a moment of true communication with my Heavenly Father. I felt His mercy and power. I felt His answer—"Yes."

The baptism shot was scheduled for 11:00. That morning, I visited with Bryan Crosland (John the Baptist) and Robert Allen (Jesus Christ) and we shared a wonderful lunch together. After lunch, I wandered outside just as the clouds broke and the light shone through. It was very heavenly. It was also eleven o'clock. I had already forgotten my promise to keep to my schedule and we hadn't even taken a shot yet.

We jumped into the motor home and sped to the lake in Arivaca, arriving at the water just before 12:00, when I had originally planned to be finished. As the clock neared 12:00, I noticed the clouds beginning to close. By the time I was taking my shots of the baptism, there were raindrops in the water.

I love how happy Christ and John the Baptist look. To many, the smiling embrace is the message of the image. To me, the raindrops in the water are a reminder that the Lord keeps His promises, even when we make the terms.

Joy

From Bryan Crosland: "When we finally got to the 'Jordan River,' I wasn't feeling excitement, I was feeling completely unworthy to represent not only John but also the life of Christ and the ordinance of baptism. Desperate prayers were offered to not only provide me comfort, but to help me know how to feel. It wasn't until later that I realized my Heavenly Father allowed me to feel those same feelings John must have felt when Jesus came to be baptized—feelings of being unprepared and unworthy and in desperate need of help.

"As Robert and I entered the water, I felt the Spirit calm me down and then Robert put his hand on my shoulder and the Spirit filled me again. The emotion and spirit of the experience was so real for Robert and me that we embraced and shared in the love of our Lord."

Walking on Water

We shot this in Rocky Point, Mexico. We carried bricks into the water as high tide was flowing into the ocean. We threw bricks out and ten or fifteen minutes later, we'd turn around and see the bricks ten feet from the shore.

While the rest of us were scurrying around, getting ready on the beach, Robert went off to the side and walked alone in the surf.

Robert said, "I thought about the Savior walking on water. The creator of all things obviously has the power to command all things, and all things respect Him, so His ability to walk on water is not a surprise to me."

I tried to get Robert to do several different things during the shoot—acting like he was stepping off a brick into the water, for example—to try to change up his balance a little bit or change his expression. In the end, we went with something really simple and regal. It looks like the Savior was out for a walk on the water.

Teacher

The sky in this photograph was a gift. I stood far away and photographed with a long lens. As I approached the group, I listened to what they were discussing. Robert was teaching the parable of the talents, verbatim, as taught by Christ in the New Testament. It was mesmerizing. Their discussion was so meaningful that I stopped shooting for a little bit, just to listen.

I wanted this shot to be more intimate than having all Twelve Apostles with Jesus. This was to portray Peter, James, and John—those who primarily led the Church after Christ's ascension.

The First Stone

From Paul Scoville: "Mark asked us to each choose a stone for the photograph of the adulteress woman. I tried to think of the spirit of the story and wanted to choose a stone that represented self-righteousness.

"As I walked back to the house at Arivaca, I realized I was still holding the stone I used in the picture. I thought, *Why am I still holding this stupid rock?* I threw it down, but the man walking next to me said I should keep that rock. He said, 'How many of us hold on to our sins every day without realizing it?' I did go and retrieve the rock. I keep it where I can see it every day to remind me to let go of all my sins and seek the healing power of the Savior's Atonement!"

From Julee P. Brady: "When it came time to physically stage the shot, I caught the images around me with all my senses: the smell of the damp dirt, the feeling of the heavy stones dropping all around me, the sound of the gentle instructions, and then seeing the image of Jesus Christ so close to me. Tears were streaming down my face.

"I remember vividly wanting to be able to touch Christ as I lay in the dirt. My hands were stretched out as far as I possibly could, and I had still fallen short of being able to touch Him. It hit me that Christ stayed in full view of me the whole time, writing a message in the sand. He was always there, wanting to offer forgiveness and to comfort me with His words and message. It was I who needed to make the effort to move closer to Him to be able to receive His blessings."

Healing

I would like to dedicate this image to my dear friend, Craig Olson—hold tight, knuckles white.

From Dirk Cline: "I was cast as the blind man Jesus healed at the beginning of his ministry. Before heading to the photo shoot, Mark asked me to offer a prayer, then he read the scriptural account from John 9. One of the crew mixed some dirt and water to make mud.

"I knelt before Robert, the man portraying Christ. His face was serene, happy, and kind. We looked into one another's eyes, and I entered into the character of a man kneeling before the Savior—pleading for a miracle.

"I placed my right hand on the small of his back and tightly clutched his robe with my left hand. With my eyes closed, I turned my face upward. Robert placed a small dab of the mud on my eyelid.

"Mark asked Robert to cradle my cheek with his hand. He asked me to show joy and gratitude. We were directed to embrace one another. Robert leaned his cheek on my head.

"At that moment, I truly felt as though I was in the arms of the Savior. I felt loved and I felt love. I felt his warm hand gently touch my face. I felt his breath as I pressed my hand into the small of his back. I felt his soft cheek rest on my forehead.

"After the final picture was taken, and I was driving down the dirt road, leaving the location, I began to weep. I pondered the life of Jesus. I marveled at how real my experience felt. I was filled with gratitude for the Savior and the actual miracle that had restored a man's sight centuries ago.

"I felt what that formerly blind man must have felt. He wanted to tell his family and anyone else who would listen that now he could see—that he had been healed by the Master. Now I wanted to share my miracle with everyone. Not a miracle of receiving sight—and not just a miracle of 'feeling' held in the arms of the Savior, which was personally powerful—but the miracle that He lives and loves us."

Wonder

This shot of Jesus with a child is the only one without a direct scriptural reference. Toward the end of the project, I began to feel disconnected from my family. I pulled my son, Marky, out of school for a few days and brought him with us on our last Mexican road trip to shoot the last few images. Knowing

that this would be a unique chance to spend some time with my son, we made some ground rules. The main rule was that when Robert put on the robes, we would pretend like Jesus was there with us. When we were set up to shoot "Road to Emmaus," I got out a costume for Marky and brought him out for this picture. Robert spent time to teach him about the creation by showing him a rock on the ground and asking Marky if knew where it came from. It was a unique chance for me to view my child in that setting, forcing me to assess my job as a father. Do I look at my child as Christ would?

TEN

"Ten" is a dance piece because that's how the image has always been presented to me. I already knew I wanted to shoot it in black and white, so it didn't matter what color the background was. I lined up the girls, took them one at a time, and said, "I want you to do this pose, I want you to jump, I want your hands this way, I want your face this way." I feel bad that for this shot, I didn't get a chance to direct them too much as to what they should be feeling, but looking back, I think that's how we got so many great expressions. The girls who were really into it and really felt it, I think it shows on their faces. And the girls who maybe weren't into it, I think you can see that, too.

PROGRESSION; COMFORT; LOVE

This sensitive moment in the life of the Savior required more concentration than any of the other shoots. Robert and I sat on the hill and had a chance to talk about Gethsemane and reflected on what we were about to portray.

I asked Robert how he prepared for the shot. He told me, "I've had different experiences preparing for this scene, but one last year was quite powerful. The names of people I know who needed Christ in their lives just flooded through my mind. I recognized the need they have because I need it as well. Christ's

atoning act redeems them—and me. I can't imagine or comprehend the weight that He bore, but I know the gratitude I feel, the same gratitude I want each of the people I thought of to feel as they connect with the offering He made. The preparation for me is remembering that this act was an act for individuals, not a collective group."

I reflected on an experience from my son's birthday party. I looked away for a moment during the swimming party and lost track of my three-year-old. I ran over to the jacuzzi and saw my son trapped under the water. There I was, the only one who saw him, with all the power to save him, so of course I jumped in the water and saved him. I thought of Heavenly Father, who knew all the pain and fear that His Son was going through, trapped under the massive burden of the Atonement, and having to stand back and not rescue him from it.

As I shot this image, I tried to look at it like a father. I think we all look at it in different ways—as a father or a son, the saved or the sinner, someone who's hoping the Atonement will bless them or someone else they love.

It was one of the few times that I've ever had to shoot through tears. I felt like a bystander in it rather than a creator. And we were blessed with an amazing sky in the Gethsemane images because, no, those aren't Photoshop clouds.

JUDAS

We had to shoot the betrayal scene without any lights because they had all been broken from the Crucifixion shoot. We used only a torch and some headlights. There's one shot where Judas is sitting there, holding a couple of coins in his hand, just looking at them. When I framed that shot, I thought, *He's just moments from his own suicide.*

It's been interesting to note that, generally speaking, successful men have

been moved by the image of Judas clutching two coins and living in misery. Most of the men who have commented on it were very generous and seemingly righteous men. Perhaps the image struck a chord with them by reminding them of their conscious decisions to not "sell out" their values.

His Stripes

The soldier on the far left of the image is my brother-in-law. He told me that as the soldiers whipped Christ, he caught Robert's eye and was moved to tears. My brother-in-law was a former nose tackle at the University of Arizona and is rarely emotional, yet the thought of witnessing the unjust beating of someone he loves simply overcame him.

Patience

The image of Christ being lead to Pilate means more to me each day as I try to grow closer to Jesus. He could have called down "legions of angels" instantly, but He knew that in order to bring us back to Him, He would have to complete the work. And He did. If we are to grow in our darkest moments, we must learn to get through them without giving up.

Crucifixion

For many of the photo shoots, we had perfect weather, but I wanted a real circumstance in which to show the crucifixion. We prayed for rain, and we got rain. But the bad weather ultimately burned out two of our three lights, forcing us to shoot the image with just one light source, which made the shot far more dramatic than originally planned.

The steady rain gave the image a really eerie feel, softening the edges and increasing the contrast. More importantly, it made people miserable. And I kept thinking, "Yeah, be miserable."

I thought about all the things that happen in the world—wars, suffering, starvation, sin—and all the things that Heavenly Father has on His mind. Maybe he wasn't really worried about our small photo shoot, but I knew He was aware of us. I knew what we were doing could change a life or two. That day, I hoped we could feel just a little bit of the pain and the mourning so we might have a greater respect of what we were trying to portray.

Robert said, "I felt a lot of compassion for the disciples who were there at the crucifixion, who were following Jesus, who saw in this man a Savior, even though some of them did not fully comprehend He was a spiritual Savior. I felt a range of emotions during the entire scene. There were people all around—some who had put Him there, some who were mourning—but none who could do anything. And then the Father withdrew."

Confession

I thought it would be important to capture one of the quiet moments of this monumental event: the recognition from the centurion that Jesus is the Son of God. It is a moment that we should all find in our lives as we, too, bow before God and acknowledge His divinity.

Patrick T. Brady Jr. played the part of the centurion beautifully. He wrote, "As the picture was being taken, I felt an overwhelming feeling of respect for our Heavenly Father and the majesty of His plan. The power and majesty of nature; the storm yielding the elements of earth and sky; the horse, whose powerful image and influence in history is standing in quiet reverence at the foot of the cross; and the physical dimensions involved with this sacred scene— all these things added to the unbelievable beauty and glory of the gift of the Atonement of Jesus Christ and His love for us."

I thought it was amazing that his horse, which was typically very perky and alert, could ignore all the people running around, the rain, and the lights, and

bow his neck for this picture. It's highly unusual for a horse to do that, but it fits the moment perfectly.

DESCENT

From Niki Worthen: "I portrayed Mary Magdalene in the Crucifixion scene as well as the photograph for 'Descent.'

"I felt a lot of pressure to convey the spirit and the emotion I thought Mary would have felt and I did not want my inadequate feelings to stifle the spirit of the pictures, so I dug deep. I read my scriptures and prayed and studied what details I could find about that day, but that wasn't enough. So I thought about my late father, of all the pain his death has brought into my life; I thought about my mother, how the hardest part of the loss of my father is seeing her pain.

"For the sake of the picture, I thought about how I would feel if I lost my husband. And when I looked up at Boyd, who was cast as a thief on a cross, the feelings were all too real. The tears came and didn't leave until the shoot was over. Yet, somehow, underneath all the pain I was feeling, I could feel a sense of peace, a sense of joy, and a sense of gratefulness to my Savior. For He saved me; He saved us all.

"I am so grateful for Mary Magdalene and her strength. What an honor it was to portray her. I hope I did her justice."

RESURRECTION

We were driving near Maricopa, Arizona, and I looked off and saw a mist. We slammed on the brakes and pulled over to the side of the road. It was perfect because the mist with the light hitting it from the sky didn't really show up as a mist in the photograph. Instead, it made the light so bright that it turned the sky white like I wanted it to without really harsh sunlight.

I love this image of Christ walking into this white brightness of day, kind of looking over His shoulder; you can barely see the nail prints in His hands. It's a different resurrection shot than any I've seen before. It's pretty triumphant.

ROAD TO EMMAUS

This image is probably the simplest in the set and it depicts one of my favorite stories—the men on the road to Emmaus. The news of the Savior's resurrection wasn't yet widespread. As the men walk, the Savior walks with them. He asks, "What's wrong?" and they say, "Haven't you heard?" They talk to Him about the horrible things that have happened to the Savior and He replies, "Wasn't that prophesied of?"

They walk until night falls and they sit to rest and to eat. They say to the Savior, "Abide with us." The Savior sits down and begins to break bread and pray. Then they recognize Him as the Savior. As soon as they do, He disappears. Later, the men talk to each other and ask "Did not our heart burn within us?"

I believe that's how the Lord communicates with us. We're not all going to see Him in the flesh while we're still alive here. But our hearts can burn within us.

When the exhibit was first set up, I noticed that the Bible that laid open in front of this image was wrinkled. When I examined it closely, I found that the page, turned to Luke 24, was bumpy because of dried tears.

LOVEST THOU ME?

I had been pondering the relationship of Christ and Peter. What did Christ mean when He asked, "Lovest thou me more than these?" I felt the Savior asking me the same question He asked Peter on the beach. Only the "fish" He was referring to were, for me, the entire creative process and photography itself.

Do I love Him as much as I loved creating these images of Him? For the first time, I had to make an effort to separate Christ the Savior from Christ the man in my pictures.

Ascension

Christ had been with His apostles for years. This was a sacred moment, saying good-bye, and that's what I wanted to reenact and capture. I wanted the body language to be clear: the Apostles wanted Him to stay, but they knew He couldn't, and some of them were happy to know it was all part of the plan.

This may have been the toughest one for the cast to act out. The men aren't professional actors, of course, and it must have been difficult to stare at a blank sky and pretend Christ was there, but every single man pulled through. I'm touched by the emotion of each of them as they react differently to the exit of the Master. I often put myself in that situation and wonder what my reaction would be.

Later, Robert told me that as he stood on the ladder and looked down at the men's eyes, he could tell they were really connecting. There was a group of strong, willing men together thinking about the Savior. In a situation like that, you can't help but be blessed by the Spirit.

ACKNOWLEDGMENTS

The Alexanders, Robert Allen, Lindsay Alston, Theresa Alston, Arivaca Ranch (Boyd Anderson, Ron Searle, John Poulsen, Norm King, Cliff Pinkard, and Carter Poulsen), Freddie Ashby, Jason and Tracy Barney, T. Dennis and Ann Barney, Clyde and Jayme Bawden, Leon and Clara Lee Bawden, Sam Bawden, Lisa Benson, Jace and Danielle Birchall, Summer and Michael Birchall, Alex Boyé, Julee Brady, Pat Brady, Melynda Brimhall, Rob Brinton, Berne Broadbent, Brandon Brown, Curtis Brown, Lee and Diann Burke, Jason Calvi, The Choir, Dirk Cline, Bryan Crosland, Gigi Curtis, Shane Dahlen, Melissa Dawes, Brad Denton, Sheri Dew, Bishop Charles Doane, Daryl Drager, Tara Duffin, The Easter Pageant Costume Staff, Kim and Kadence Eaton, EBuilt Construction, Jana Erickson, Richard Erickson, Tonya Facemyer, Keighley Fleming, Elena Gomez, Chelsea Gooch, Alexis Gremillion, Matt Gunson, Kayla Hackett, Gail Halladay, Todd Haser, Nanci Jo Hancock, John and Rhonda Hogle, Larry Howlett, Elaine Huish, Chelsea Hunt, Rusty and Melanie James, Kali Jarvis, Howard Karger, Gilberto LaParra, Mele Larson, Wayne Leavitt, Mark Lusvardi, Al and Helen Mabry, Mark and Jerri Mabry, Lisa Mangum, Matage Custom Framing, Kevin McCain, Richard Morris, The Mystery Donor at my door, Amber Neel, The Paint Crew, Catherine Papworth, David and Darelyn Peterson, Bill Pollard, Steve and Liz Porter, The Pothier Family, Aaron Pratt, Pure Touch Media, Craig Raey, Amanda Rasmussen, Paul Rowley, Keith and Audrey Ryan, Chris Schoebinger, Paul Scoville, Hope Sheperd, Doug Shumway, Garrett Smith, Loren Smith, Sheryl Dickert Smith, Erica Soelberg, Tantrum Salon, Randy Thomas, Cameron and Rechelle Trejo, Torrin Turley, Boyd Ware, Dixie Waters, Kacie Williams, JC Wilson, Lynne Wolfe, Kimberly Woodruff, Boyd Worthen, Niki Worthen, John and Nanci Wudel